IMAGES
of Sports

CLEVELAND'S
GREATEST FIGHTERS
OF ALL TIME

To my wife, Deborah Rose, who has always been at my side with love and understanding, especially in our early years together, when boxing took up a lot of my free time; and to all the fighters I write about, their remarkable careers, and in some cases such as Jimmy Bivins, George Pace, and Joey Maxim, their friendships which meant more to me than they will ever know. This book is for them.

IMAGES
of Sports

CLEVELAND'S
GREATEST FIGHTERS
OF ALL TIME

Jerry Fitch

ARCADIA

Published by Arcadia Publishing,
an imprint of Tempus Publishing, Inc.
3047 N. Lincoln Ave., Suite 410
Chicago, IL 60657

Printed in Great Britain.

Library of Congress Catalog Card Number: 20021047759

For all general information contact Arcadia Publishing at:
Telephone 843-853-2070
Fax 843-853-0044
E-Mail sales@arcadiapublishing.com

For customer service and orders:
Toll-Free 1-888-313-2665

Visit us on the internet at http://www.arcadiapublishing.com

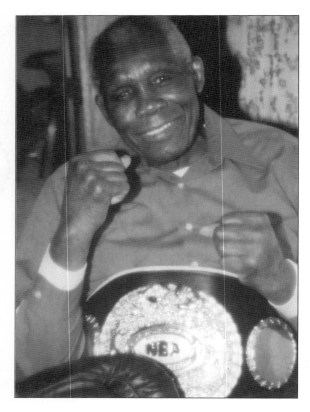

JIMMY BIVINS PROUDLY WEARS HIS
NBA "DURATION" HEAVYWEIGHT
CHAMPIONSHIP BELT, 2000.
(Courtesy of the Bivins Family.)

CONTENTS

ACKNOWLEDGMENTS

There are so many people who helped make this book possible, especially the fighters I was able to interview one-on-one. Heartfelt appreciation goes to them for always being so candid with me. My deepest appreciation goes to Thomas Greer and Bob Dolgan of the *Plain Dealer*, for helping me with old photographs over the years. In many cases, I do not even know the sources of some of the material and photos I was able to obtain over a lifetime, but I do acknowledge the former *Cleveland News* and *Cleveland Press*, and their photographers—surely some of these photos came from them along the way. And thanks to Terry Gallagher for his photos, and for always being there for me.

Thanks to my good friend, Donald "Captain" Myers, who introduced me to Jimmy Bivins in the late 1960s, and was my partner in many boxing adventures over the years.

And I don't know how to say thank you to Irv Abramson of Miami, and the National Boxing Association for righting a 55-year-old wrong when I was able to present Jimmy Bivins with the NBA "Duration" Heavyweight Championship belt in July of 1998.

I would be remise if I did not mention Tom Huff of *Boxing World Magazine*, whose generous help in putting this all together I would have been lost without. And a special thank you to my son, Tad Fitch, whose help was special.

INTRODUCTION

State law made the sport illegal in Ohio from 1830 until the law was amended in 1923. Boxing was frowned upon throughout the United States in those early days, and Ohio joined in on the ban, so there were always stories of crowds at clandestine bouts fleeing from the raiding sheriff. Despite the law and the disapproval of the general public, however, boxing appears to have its beginnings in Cleveland in the late 1880s or early 1890s, and one record even shows boxing being introduced here in 1861 by one of the fabled characters of the sport, John C. Heenan, claimant to the heavyweight title. He appeared at the Academy of Music, not for a fight, but as a guest. Although Heenan did not appear in a boxing match, according to S.J. Kelly's historical account years later in the *Plain Dealer,* he did get tangled up in a fight that broke out between two men in the orchestra circle. The audience was cheering the fracas when the curtain suddenly parted and Heenan, leaping from the stage, seized a combatant in each hand. One was tossed behind the curtain and the other arrested.

A lapse of twenty years occurred before any more accounts of fight action appeared. In October of 1881, American Champion Paddy Ryan and Charley McDonald, the Canadian champ, met in a bare-knuckled contest at the City Armory. The exhibition was won by Ryan with a fourth-round knockout. Another ten years lapsed before fight action resumed, this time at the Cleveland Athletic Club in 1891. But not many bouts were held in this era with the sport being officially "illegal."

During those early days of Cleveland boxing history, fights would often take place on what is now called Whiskey Island, a good location to escape notice of the authorities. A lot of these fights were no more than brawls between local citizens, many of them workers from the iron ore docks. Sometimes it was just to settle an argument or to work out frustrations. They would fight until one or both of the combatants dropped from exhaustion.

According to the late, great boxing historian Dan Taylor, the first legalized World Championship match in Cleveland history was held at the Central Armory on March 17, 1898, between George "Kid" Lavigne of Saginaw, Michigan, and Wilmington Jack Daly. The Armory was crowded to the doors, and it is said that scalpers sold ringside seats for $10 each. Fans from Chicago, Detroit, Toledo, Columbus, Cincinnati, Youngstown, Louisville, Pittsburgh, Philadelphia, Erie and Buffalo attended with Cleveland-area boxing fans to see Lavigne defend his lightweight tile. The fight ended in a twenty-round draw.

Taylor went on to say that the only bouts staged before 1898 were held in private clubs for members only, and those were staged "on the sneak." Armory promoters prevailed upon a lenient city administration to bring the fight game out in the open for a trial. That was how the Lavigne-Daly bout was able to be held.

In the late 1890s, Cleveland also saw the appearances of two of boxing's all-time greats in middleweight champ Kid McCoy and lightweight champ Joe Gans. And as the early 1900s came around, Cleveland would host many famous fighters, but not always in actual fights. John

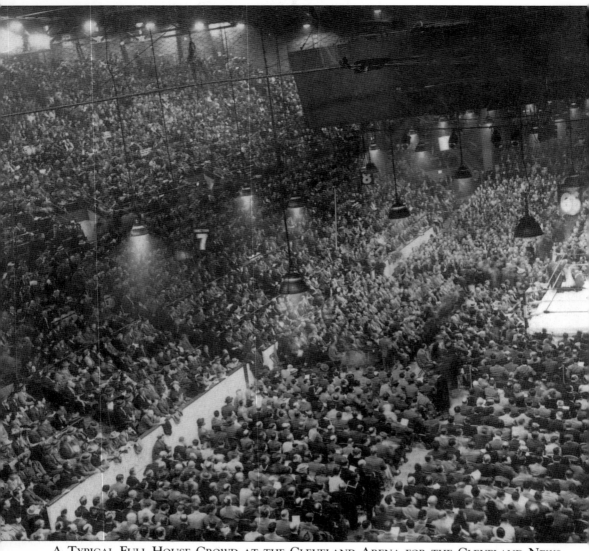

A TYPICAL FULL-HOUSE CROWD AT THE CLEVELAND ARENA FOR THE CLEVELAND NEWS TOYSHOP FUND SHOW ON DECEMBER 2, 1947. This scene is a far cry from the image of a surreptitious crowd of dock workers hoping to evade authorities at an illegal, bare-knuckle

brawl on nearby Whiskey Island, which would have been one of boxing's only local venues half a century earlier.

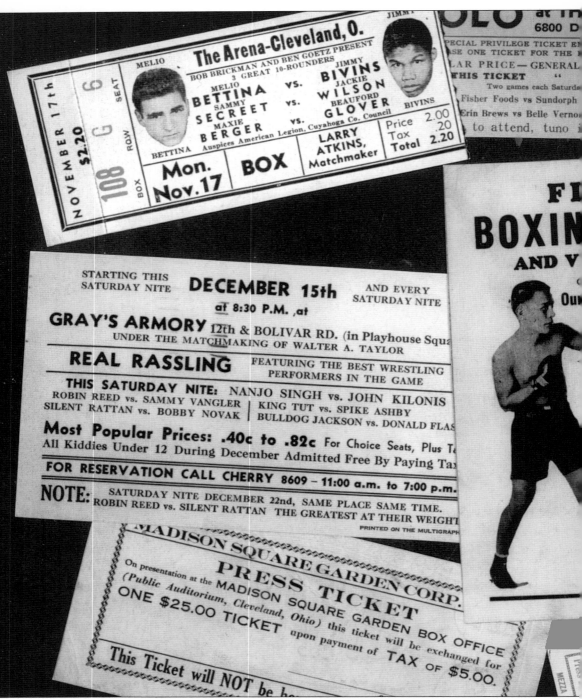

COLLAGE. This Collage of Advertisements and ticket stubs represent some of the greatest names and places associated with the golden age of Cleveland boxing. Gray's Armory, at 12th and Bolivar Road, was the scene of some of the first fight action in Cleveland. It is still used today for occasional boxing shows. The Cleveland Arena, built in 1937, and the 80,000

10

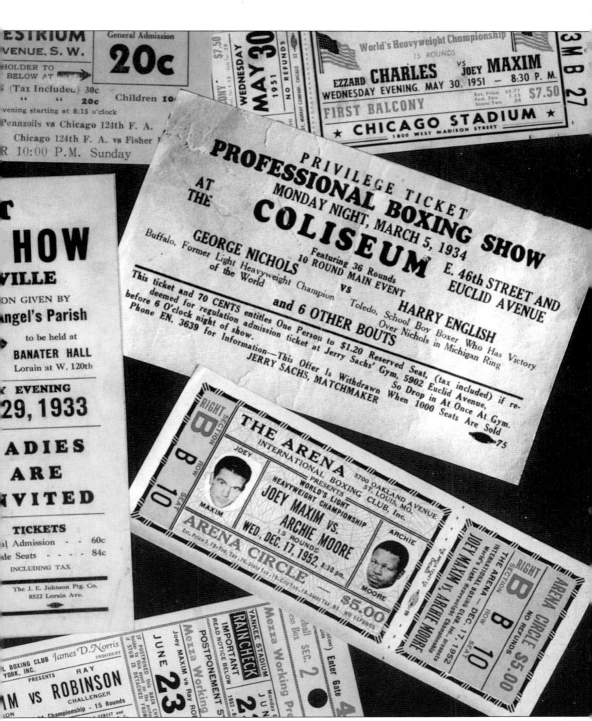

capacity Cleveland Municipal Stadium, which hosted the Max Schmeling-Young Stribling Heavyweight Championship fight on July 3, 1931, as its inaugural event, became the two most popular venues for marquee bouts.

L. Sullivan, Jim Corbett, and Bob Fitzsimmons—the first three heavyweight champions in modern boxing history—all appeared here either in burlesque or in another sort of theatre production. Corbett, the only one of the three with actual acting ability, made a career on stage after his ring days were over.

Another heavyweight who brought some life to the boxing scene was Professor John Donaldson. He fought Sullivan in 1880, and boxed a four-rounder with Corbett in 1885. Donaldson moved to Cleveland after his ring days were over and opened a boxing school. He gave local amateur boxing its first real shot in the arm and even attracted some pupils from the more "upper-class" elite, including Eugene Ong, son of a prominent judge of the era, Walter C. Ong. Young Ong went on to win the 1896 Heavyweight Boxing Championship of University School in Cleveland. He then went on to Yale and won the championship there, and on to Harvard Law School were he did the same, before finishing his schooling and returning to Cleveland. That is when a funny story developed, as the young Ong secretly told his friends that he could beat his old teacher, Donaldson, in an actual bout. They fought an exhibition in the gymnasium one afternoon and all went well for a few rounds, until Ong decided his old instructor was ripe for the kill. He is said to have charged forward, and Donaldson, stepping back, threw one right hand and the young Ong ended up out cold. He sported a big shiner for a couple of weeks, and this ended his fistic ambitions, as he became a fine attorney in Cleveland and eventually New York City.

The first local boxer to gain any sort of national fame was Phil Brock, who ushered in the early 1900s with several important victories over high-ranking fighters. Later on, his brother Matt fought some major bouts too. Of course, Jack Kid Wolfe and Carl Tremaine had a huge impact on the early days of Cleveland boxing, and both have chapters of their own in this book, and rightfully so. To say such fighters simply contributed to the history of pugilism in Cleveland in those early days would be a gross understatement.

But the man who really gets the credit for putting Cleveland on the boxing map is Johnny Kilbane. Others had their moments, but none had as big an impact on the sport. Kilbane was the World Featherweight Champion, holding that title for longer than any other fighter in history. He was so famous that he remained a very popular figure long after his fighting days were over.

Johnny Kilbane really begins the era of Cleveland's Greatest Fighters of All Time.

One
JOHNNY KILBANE

JOHNNY KILBANE, CLEVELAND'S FIRST GREAT FIGHTER.

John Patrick Kilbane was born on April 18, 1889, in Cleveland, of Irish stock. He came out of hard times on the Cleveland ore docks to become Cleveland's first world champion. Starting as a raw-boned skinny kid weighing 110 lbs. at 18 years of age, he entered the boxing world in 1907 to help support his blind father and two step-sisters. Little did the Cleveland boxing world know that this frail looking Irish lad was soon going to become a very prominent figure in the fight world for many years to come.

After falling under the watchful eye of Jimmy Dunn, a pretty fair ring battler in his own right, Johnny turned pro with very little experience under his belt other than street fights on the docks and in the Westside neighborhood he grew up in.

Actually, it was a chance meeting with Dunn that got him into boxing, as Kilbane had no childhood desires to one day become a boxer. Dunn, who was training for an important match, badly needed a sparring partner because his regular, George Frazier of nearby Lorain, Ohio, had hurt his hand. As fate would have it, the Westsiders elected Johnny Kilbane to do the sparring and after a few hectic rounds, Jimmy Dunn was impressed with his speed and poise for one so green in the fight trade. Dunn invited Kilbane back to his training camp anytime he liked, and history proved he made the right decision, the right decision for both men. One became a manager and trainer of note, and the other world featherweight champion.

Johnny Kilbane had success early in his career, but probably was most famous locally for a grudge fight held with his namesake, Tommy Kilbane, who just happened to live on the next street over from Johnny. Although not related to Johnny, he was about the same size and fancied himself a fighter. A rather strong jealously developed between the two young men, and it would appear Tommy wasn't at all thrilled with all the fame and acclaim Johnny was getting

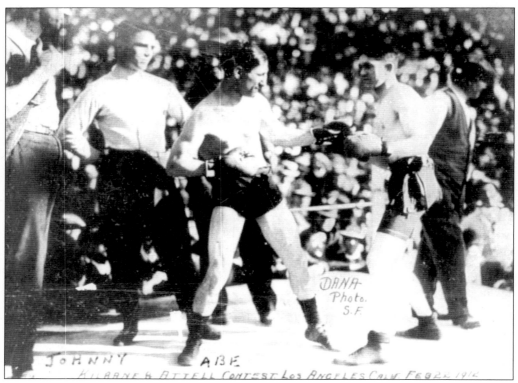

JOHNNY AND ABE ATTELL SQUARE OFF FOR THEIR CHAMPIONSHIP FIGHT IN VERNON, CALIFORNIA, FEBRUARY 22, 1912.

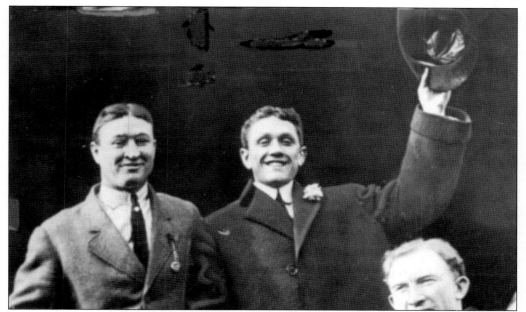

JOHNNY KILBANE AND JIMMY DUNN IN A VICTORY PARADE AFTER WINNING THE FEATHERWEIGHT TITLE FROM ABE ATTELL, FEBRUARY 1912.

from his early pro bouts. It turned out to be a bit of a bitter thing as the two Kilbanes often ended up slugging it out on the streets. Although Tommy was not a boxer at the time, he figured he sure as heck could be one, because he had held his own with his neighborhood rival. So Tommy turned pro, and eventually these men were to meet several times in the squared circle. Finally, a 25-round grudge match was set up, and they jammed the place until it wouldn't hold anymore and then the two put on a wonderful war that had everyone on the edge of their seats for 23 rounds. Finally in the 23rd round, Johnny floored his rival, and although he got up that turned the fight around and proved to be the winning margin. Referee Johnny Ruddy called Johnny Kilbane the winner after 25 brutal rounds.

Johnny continued to fight around the circuit and did quite well, with many bouts ending in the no-decision ruling of the era. But he was winning, there was no doubt about it, and he didn't officially lose a contest until October 24, 1910, when Abe Attell won a ten-round decision over him in Kansas City. Johnny came right back into the winning habit after the first Attell bout, until "Indian" Joe Rivers managed to defeat him over twenty rounds in Vernon, California, on May 6th of 1911. In September of the same year, in a rematch, Johnny was to knock out Rivers in 16 rounds.

Winning became a habit, and his previous fine showing against the champion, Abe Attell, sure helped Kilbane's status, so Johnny was given a second chance with the man who had held the crown for so long. And the second time proved lucky, as Johnny Patrick Kilbane became Cleveland's first world champion via a 20-round decision over Attell on February 22, 1912, in Vernon, California.

It has been said in history that Johnny Kilbane was a reluctant champion, that he wouldn't put his title on the line. It may be true, because although Johnny held the championship for a record of almost twelve years, he only officially defended it a total of seven times. But to say he was inactive would not be justified, for the boxing public got to see the world champion in action in many cities across the country. He had 23 bouts in 1913 alone!

JOHNNY SPARRING WITH AL CORBET.

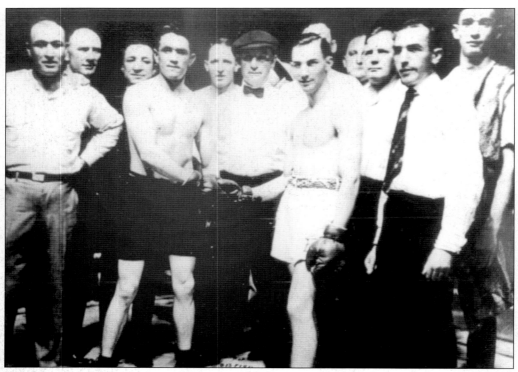

JOHNNY KILBANE AND BENNY LEONARD BEFORE THEIR APRIL 29, 1915 NO-DECISION BOUT. Most of Johnny's bouts ended in the No-Decision verdict of the era, as previously stated, so it is awfully hard to tell his true worth. But he was fighting some good men such as Benny Leonard, Kid Williams, Jimmy Walsh, Cal Delaney, Rocky Kansas, Matt Brock, and Freddie Welsh. Only the great Leonard was able to dent his armor, as Johnny was stopped in three rounds in Philadelphia on July 25, 1917.

JOHNNY KILBANE AS A BOXING INSTRUCTOR DURING WORLD WAR I, 1918. For the record, Johnny defended his title against Jimmy Walsh in a twelve-round draw in Boston in 1912; Johnny Dundee in a twenty-round draw in Vernon, California, in 1913; Eddie O' Keefe in a first-round knockout in Philadelphia in 1913; and against George Chaney in a third-round knockout at Cedar Point in Sandusky, Ohio, in 1916. Then came World War I. During all of 1918, Johnny was a boxing instructor at Camp Sherman, but in 1919 he resumed his career and his reluctance to give up the same, as he had prior to the war.

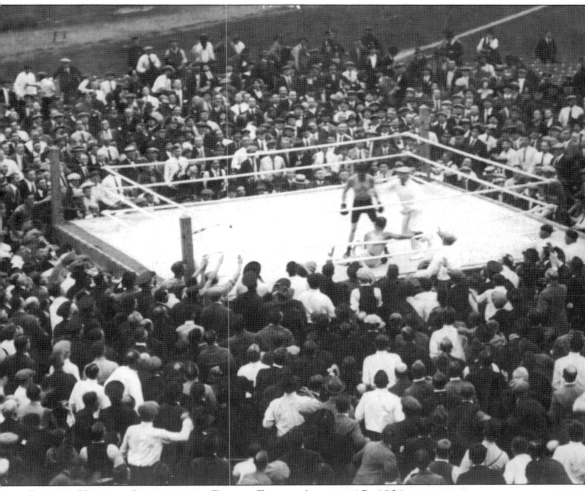

JOHNNY KILBANE STANDS OVER DANNY FRUSH, AUGUST 17, 1921.

In 1921, Johnny started slowing down to a crawl and only had two bouts, one a title defense against Danny Frush before his hometown fans. In the previous year he had been active with seven bouts, including a title defense against Alvie Miller, won by seventh-round knockout in Lorain, Ohio; so it looked like the handwriting was on the wall.

In 1922, Johnny didn't have a single bout. Finally, in 1923, with threats to strip him of his crown, he put it on the line against Eugene Criqui, the French war hero, who Humpty-Dumpty like had to be put back together again. Criqui belted Kilbane out in six rounds on June 2, 1923, in New York City.

In 142 recorded bouts, Johnny had 114 wins, 25 by knockout, 12 losing decisions (newspaper decisions mostly), and 12 draws. He also won one bout by foul, one by no contest, and was knocked out twice. Johnny was not known as a big puncher, although he packed a pretty fair wallop in his right hand. Even his strongest critics would marvel at his boxing ability, and speed of both hand and foot. It can be safely said that Johnny Kilbane *was* Cleveland boxing for a long time and truly put it on the world boxing map.

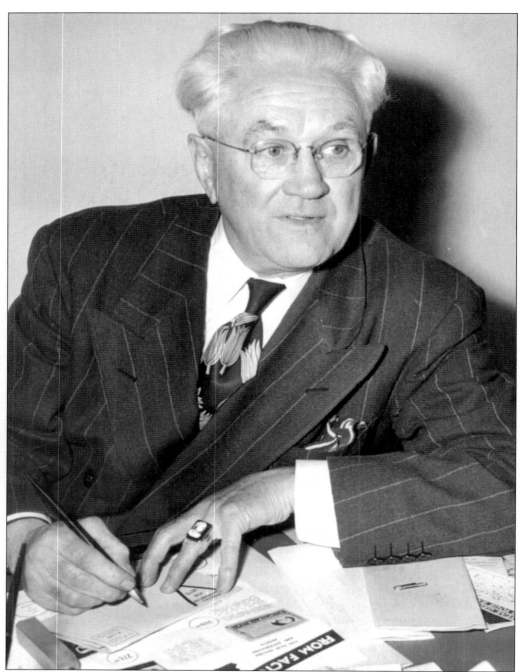

JOHNNY KILBANE AS CLERK OF COURTS, 1949. After retiring, Johnny taught boxing for a while, owned a gym, and was modestly successful in Cleveland politics. He was always popular, and a very friendly man, they say. Although it had been rumored that he was ill for sometime, it still came as a shock when he departed the good earth on May 31, 1957, in Cleveland, Ohio, at the age of 68. And somehow you figured he would live longer. After all, he was reluctant, wasn't he?

Johnny was elected into the first of several boxing halls of fame in 1960.

Two

CARL TREMAINE AND JACK KID WOLFE

CARL TREMAINE.

odern day fans know all about Johnny Kilbane and Joey Maxim being famous Cleveland greats and world champions. But only a few old-timers remember Carl Tremaine, the Canadian-born Cleveland battler of 1917–1929.

Born in Listwell, Ontario, on August 26, 1899, he remained in Cleveland throughout his active days, and eventually passed away here in the early 1930s. The 5-foot-3-inch bantamweight fought in an era of the No-Decision bouts and had a reputation of a guy who would fight often and meet all comers; indeed, Tremaine feared no one. Many of his fights were held in Detroit, Toledo, and the Cleveland area.

CARL TREMAINE (FAR RIGHT) WITH CLEVELAND FIGHTERS AND CELEBRITIES, C. 1920S. From left to right are Al Corbett, lightweight; Jimmy Dunn, manager of Johnny Kilbane; Bryan

Under the astute management of Jimmy Dunn, of Johnny Kilbane fame, Carl was soon to become the most exciting and controversial fighter of his era, or any era, in Cleveland. He could be crafty, he packed a wallop, and when it came time to get down and dirty, he could do that also.

And while he was famous for meeting local rival Jack Kid Wolfe, and champions such as Mike Ballerino, Tommy Ryan, and Frankie Genaro, he was most famous for his February 24, 1925 bout against the world bantamweight champion, Eddie Cannonball Martin, at the Public Auditorium. To many in the crowd of over ten thousand screaming fans, and to sportswriters alike, this was "The Greatest Fight in Cleveland Boxing History."

Downey of Columbus, Ohio, claimant to the middleweight title; Johnny Karr; and Carl Tremaine.

When I write of these men who fought in that era, I have to go by the record books, newspaper clippings, and—if I am lucky—the occasional old-timer that remembers those days. Add that to the fact that there are normally no films available of most of the men, and I am in a fix when it comes to gauging how good the fighters really were. But like all things historical, I do not want to lose what some of these men accomplished to laziness or lack of not caring. I do care, and hope that whenever I write of these men I do them justice.

The no-decision bouts leave you guessing unless you scan the microfilm of the old newspapers, and see who the writers picked as the winner, ringside. Even then I am not sure that is a fair appraisal, because in hometown bouts, many writers became "homers" and gave the call to the local guy.

One thing is for sure though, Carl Tremaine averaged over 13 bouts a year for his entire career, and that is something nobody today could even imagine. One hundred and thirty-four bouts is a long, tough career, and to say they don't make fighters like that anymore would be an understatement.

Carl won most of his fights, and when he lost he usually came back to defeat the opponent in a rematch. Prime examples were his fights with Joe Burman, champion Tommy Ryan, and Charles Goodman, who knocked out Carl in seven rounds in May of 1924, but then lost a return match to Carl in October of the same year.

But the Tremaine-Martin match was amazing in many ways because it also featured local promoter Walter Taylor, stealing the match away from the famous Tex Rickard, by offering Martin the unheard of sum of $7,500, which is hard for anyone to fathom in these days of mega bucks.

So, 10,000 fans jammed the Public Auditorium and another five thousand had to be turned away. And although Martin agreed to fight to a referee's decision, he also insisted that Tremaine came in at 120 pounds, over the bantamweight limit, so Carl could not claim the title if he won.

The two ended up weighing in at 121 pounds, and title or no title, Carl proceeded to take it to the tough Martin round after round, and Martin gave back as good as he got. Most of the early rounds went to Tremaine, as the fans stood and screamed their lungs out. It seemed as if they couldn't keep up the pace for a full twelve rounds, but Carl was determined to do just that. And although Carl hit the deck in round two, he delivered the most punishment, but still he could not dent the champ's armor, and never seriously had Martin close to toppling off his feet.

Carl tired towards the end of the fight, worn down from his constant punching against the tough and resilient Cannonball. Proving how hard he had been punching, when the gloves were cut off at the end of the action, both hands were soaked in blood. An examination revealed he had broken the first three knuckles on both hands.

Carl was asked how he felt when given the decision by the referee and all he could say was, "Hitting Martin on the jaw is like hitting an iron horse. I hit him with everything I had and all he did was grunt."

Later, Tremaine was seen with tears running down his cheeks, and somebody asked him, "What's wrong, Carl, are you hurt?" "Naw," he replied. "It was those fans. Did you hear the cheers they gave me tonight? That's the first time that ever happened to me in Cleveland and I guess I just can't take it. I feel funny all over." Sportswriters found this moment unusual, because normally Tremaine was a wildman, often called heartless in the ring. Not only did he show a different side, he also fought one of his cleanest fights locally, and the fans wanted him to know they appreciated it.

Carl fought four more years after the Cannonball Martin fight, and he would win some thrilling fights and lose some not so thrilling fights. But he never regained what he had that night against Martin, and in 1929, after a brief comeback, he was finally stopped in seven rounds by Mickey Doyle, and called it quits.

In 134 fights, Carl only officially lost 14, while winning 59, with 6 draws. The rest of the fights were listed as no decision, 55 in all. In addition to the champions he met, there were others like Pete Zivic, Young Montreal, Pete Sarmiento, Earl Puryear, Memphis Pal Moore, and local opponents like Johnny Farr and Benny Gershe, who can say they felt the sting of the wildcat from Listwell, Ontario.

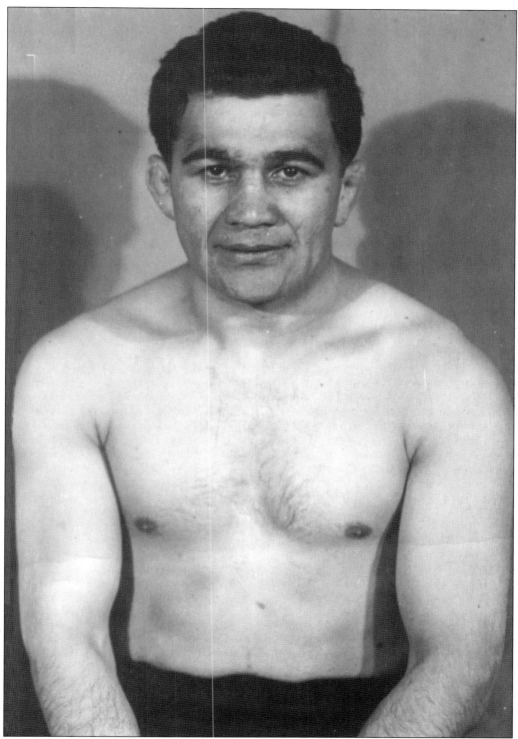

JACK KID WOLFE.

Cleveland produced many excellent fighters like Carl Tremaine long before I was born. Some of the names I read about in old newspaper stories, or while going through microfilm, and one that caught my eye for a different reason was Jack Kid Wolfe. Although I had read about him and some of his bouts, what made me sit up and take notice was the 1986–1987 *Ring Record Book*. This was the last regular year of publication for *The Ring Record Book and Encyclopedia*, and in it, the editor, Herb Goldman, along with many loyal historians and fans, updated many records, poured over microfilm, dug into the archives, and found many mistakes, missing bouts, and new information.

On Page 440, the record of Cleveland's own Jack Kid Wolfe was listed as the World Junior Featherweight Champion in 1922, something I had never heard or read about before. He defeated Joe Lynch in New York over 15 rounds on September 21, 1922, and it was listed as a world title bout.

Jack, born in Cleveland on June 11, 1895, turned professional in 1911, and his record is cluttered with the no-decision bouts of the era. The Ring took time to have many of us who do research read the old stories about the fights, and in some cases we were able to render a "newspaper" decision for one of the men. Here again, you have to take into account that local writers may have favored the hometown boy on some occasions.

At any rate, the 5-foot-2-inch Clevelander, who was managed by Tommy McGinty, turned pro in 1911, fighting mostly as a bantamweight in the Cleveland area. One of his local rivals was Cal Delaney, whom he met three times in the first year, and they ended up on even terms— not much to choose between the two local battlers.

By 1913, Jack started venturing out to New York City, and other cities, to take on more nationally known battlers. A few of the men he met in New York were Kid Herman, Willie Doyle, and Eddie O' Keefe.

By late 1916, he was back fighting mostly in Cleveland, and he was averaging one fight per month. Local promotions did not hesitate to put him on a card, as he was an action fighter who "gave it his all." Soon he was meeting Memphis Pal Moore, Willie Devore, Johnny Ertle, and Joe Lynch on local fight shows.

From 1916 to 1920, Jack's record—mostly in the Cleveland area—showed a total of 64 fights with only 4 official losses, and these bouts were mostly against quality opponents such as Memphis Pal Moore and Joe Lynch, who defeated him twice each. But Jack defeated many good men himself including Moore, Artie Root, Pete Herman, Lynch, Earl Puryear, Jack Sharkey, Joe Burman, and Harry Coulon.

It wasn't until April 21, 1921, that Jack Kid Wolfe really tasted a serious defeat, as Danny Kramer, a southpaw slugger from Philadelphia, put the ten count on Wolfe in the fifth round. Up till that point, Jack had defeated many of the top bantamweights and featherweights in the world, including four world champions in non-title bouts, and seemed almost invincible. When referee Tommy McGuire hit ten, many in the seats actually shed tears for their fallen idol. Wolfe had been winning the fight easily when he got careless, and it is said a ton of Cleveland money went down the drain that night when the local hero tasted defeat.

But the very next month Jack went right back at it. He defeated Kid Williams and continued on his winning ways against mostly good fighters such as Alvie Miller and Frankie Jerome. Then, according to the *Ring Record Book*, he was matched with Joe Lynch in New York City for the Vacant World Junior Featherweight Title, and he won it over 15 rounds. The bout took place on September 21, 1922.

For the remainder of 1922, and throughout most of 1923, Jack Kid Wolfe was matched against good fighters, but was not having as much success as previously, losing four fights, drawing twice and winning five. Sammy Mandell, who would go on to win the lightweight title, defeated him twice by decision. But none of the fights were for Jack's newly won crown.

Finally, on August 29th, he met Carl Duane in Long Island in defense of his title, which was lost over a 15-round decision. There had not been much glory to the title, and certainly not much money either.

JACK KID WOLFE, SHADOW BOXING LATE IN HIS CAREER. Jack met seven world champions, defeating five of them; overall, was 8–7–1 in fights against champions. His title, well, you tell me, was it really recognized and worth mentioning? I have never seen it listed or written about in any Cleveland articles. But one thing is for sure, Jack Kid Wolfe was indeed one of Cleveland's Greatest Fighters of All Time, no doubt about that! He died on April 22, 1976, in Cleveland.

In 1924, Jack Kid Wolfe defeated Young Montreal, and drew with Leo Roy, in Montreal, and then met local rival Carl Tremaine in Cleveland. He and Carl had waged what was called a "savage draw" in July of 1921, but this one did not live up to its billing, and Tremaine charged across the ring and floored Jack, and had him down several more times, delivering a tremendous beating which had the fans screaming for the referee Matt Hinkle to stop the fight. Even Carl leaped to his feet and joined the crowd in begging that the fight would get stopped. Wolfe's manager, Tommy McGinty, did not want the fight stopped, and Tremaine screamed in his face, "What do you want me to do, kill him?" Finally, cooler heads prevailed and the fight was stopped.

Jack tried it one more time in 1925, lost a decision to Bobby Reynolds, and called it quits. He was one of the most popular fighters in Cleveland history, and left behind a total of 136 fights, with 71 being listed in the win column with only 20 defeats, 22 draws, and the rest being listed as no decisions, even after *Ring Record Book* completed their update.

Three
JOHNNY RISKO

JOHNNY RISKO.

In June of 1924, Johnny Risko engaged in what was only his fourth professional fight, and his opponent was a seasoned veteran named Homer Smith. It proved to be a contest that would alter the career of the "Baker Boy" tremendously. Some record books show the result as a No Decision, while others list it as a draw. The result, however, wasn't nearly as important as what actually took place during the bout.

Johnny was winning the fight, when he threw a wild right hand at Smith in the seventh round, and as Smith ducked, Johnny fell forward across Smith's shoulders, tearing his right arm clean out of its socket. He managed to survive the last four rounds with his chief weapon hanging loosely at his side.

A six-month layoff followed, and he returned to the ring wars as a left-hooker with his main knockout weapon, his right, never returning, not even during his glory years. It is hard to say whether or not Johnny Risko would have been more successful had he not ruined his right shoulder that day in 1924. But it really didn't seem that his success could have been much greater with it, unless you figure that he might have gotten that elusive title shot.

Johnny was born in Austria, on December 18, 1902, and came to America with his family at an early age. His family ran a bakery on the Westside where he worked, thus he was stuck with the name "Baker Boy" throughout most of his early career. Later on, many called him the "Rubber Man" because of his ability to take punishment and bounce right back.

When Danny Dunn first saw Johnny Risko, he probably laughed. Johnny never did give off the impression that he was a fighter. Standing only 5 feet, 10-or-11 inches tall—depending who you believe—and weighing 184–210 pounds, he really never looked in shape, always had a sort of pudgy look to him, and certainly did not strike fear into his fellow man with his physical appearance.

Whatever it really was that made businessman Danny Dunn take Risko under his wing may never be known. But the net result shows that Danny made a very smart move. Risko may not have looked like a fighter, nor did he have great physical tools, but he had a heart that drove him on and a jaw as solid as granite. He wasn't afraid to fight anyone, no matter how much they weighed, or how tough they were. The first year as a pro saw Johnny mixing it up with some pretty fair ring men such as Mike Wallace, Joe Downey, Martin Burke, and Quintin Romero-Rohas.

1925 showed that Johnny was more than an ordinary warrior, as he really got into some very big matches with the likes of Young Stribling, Jack Sharkey, Chuck Wiggins, and Gene Tunney. The Tunney fight, although a loss over twelve rounds, showed how much heart Johnny had, and what he was made of, as he gave the "Fighting Marine" all he could handle in a close fight. To quote Tunney after the bout, "He's the toughest man I ever fought."

Danny Dunn always claimed that the fine showing by his "big fella," as he liked to call him, cost them a title match. "Gene never forgot the rough time my big fella gave him," Dunn said. Dunn claimed Tunney hand picked Tom Heeney of New Zealand over Risko, and then retired. Whether it is true or not is hard to say, but no one can deny Johnny Risko gave Tunney a tough battle.

Weighing mostly in the 184-pound range, Johnny was able to fight not only the best heavyweights around, but also the pick of the light-heavyweight ranks. In 1926 and 1927, Johnny met the best of both weight classes such as Mike McTigue, Tommy Loughran, Jack Delaney, Young Stribling, Joe Sekyra, Tom Heeney, Chuck Wiggins, and Paolino Uzcudun. But 1928 really put a star on Risko's reputation as a spoiler, as he bested future heavyweight champion, Jack Sharkey, over 15 rounds in New York. Then he won over giant George Godfrey by decision, and also beat Bearcat Wright. Size didn't mean anything to the pudgy looking Austrian, and Dunn and everyone else started becoming true believers.

JOHNNY'S WIFE CHECKS HIS MUSCLES PRIOR TO THE JIMMY MALONEY FIGHT, 1934, WON BY RISKO BY DECISION.

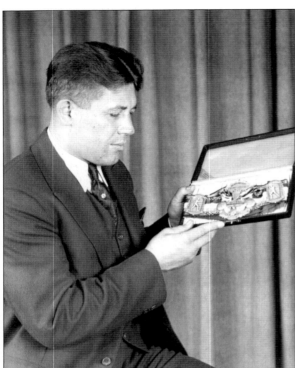

JOHNNY LOOKS AT THE CHAMPIONSHIP BELT HE HOPED TO WIN ONE DAY.

MAX SCHMELING (RIGHT) AND JOHNNY RISKO WEIGH-IN. Pictured is the weigh-in for Schmeling and Risko's February 1, 1929 fight, which saw the future Heavyweight Champ knock out Johnny in nine rounds.

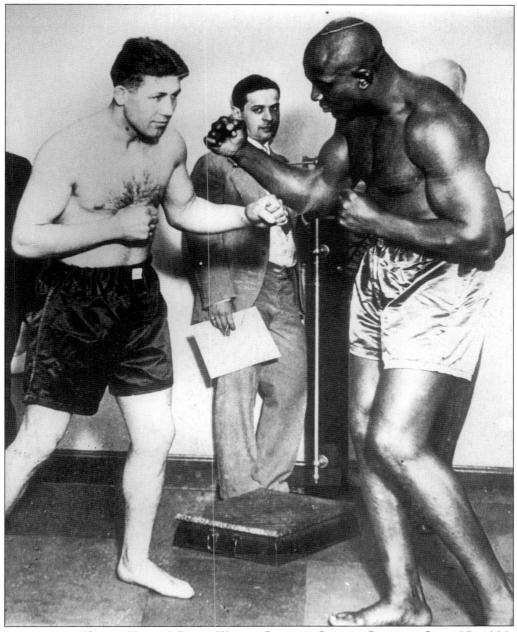

Johnny the "Giant Killer" Risko weighs-in with George Godfrey, June 27, 1928, in New York City.

Don't get me wrong, Johnny Risko wasn't unbeatable, and sometimes was made to look very ordinary by less than top-notch opponents. And a lot of the light-heavyweights were too fast and evasive for the game Risko. But when the chips were down, he always seemed to come up with the big win at the right time. Very few heavyweights of any era could boast of the victories that he held over top-notchers of his day.

Johnny Risko wasn't what you could call a predictable fighter. Although his usual style was to lower his head and come bulling forward, taking lots of punches and giving lots in return, he could alter his style and method if the opponent required such. For example, on September 14, 1927, in Cleveland, Johnny met the hard hitting and clever Jack Delaney, former world light-heavyweight champ. Although he outweighed the Canadian by twenty pounds, most experts figured Delaney would have little trouble out-boxing Risko, as other fast light-heavies had done over the years. But Risko proved them all wrong as he completely changed his style, turning boxer to dominate the first five rounds of the contest. Even a Delaney rally in the sixth wasn't enough to turn the bout around, and Johnny did enough in the last few rounds to hang on to his lead and gain the decision.

After his wins in 1928 over Sharkey and Godfrey, Johnny went on to bigger and better things. But he more than met his match on February 1, 1929, in New York as future heavyweight champion Max Schmeling blasted him into defeat in nine rounds, Johnny's first kayo loss.

Nineteen twenty-nine proved to be a rough year, as Risko lost five other bouts, three by fouling out. But he did manage to end the year on a good note, by knocking out toughie Jimmy Maloney in two rounds and winning a decision over Ernie Schaaf, both bouts being held in Cleveland.

In 1930, the "Rubber Man" again played the spoiler roll as he beat the big Basque, Paolino Uzcudun, for the second time, this one in a heavyweight elimination bout staged by Tex Rickard. But 1931, '32, and '33 proved the best three years overall of Johnny's career.

He started out slow in 1931, with no wins in his first four bouts, but on April 6th he defeated Tom Heeney in Toronto and finished up with a decision over the fish peddler, "Kingfish" Levinsky, in Boston, the following month. On May 5th, he met a young, brash, big hitting heavyweight from the west coast, who was to go on to become heavyweight champion. I speak of Max Baer, the lovable, laughable big clown with the deadly right hand. Johnny emerged the winner once again, and now he was much in demand by promoters all over. He defeated "Two Ton" Tony Galento, KO Christner, and Kingfish Levinsky again. He lost a close one to Tommy Loughran, former light heavy champ, and also was bested in a return match against Baer. But he ended the year with another win over KO Christner.

1932 was a lean year as far as number of bouts go, but the three he did engage in ended up in the win column over some pretty fair foes—Mickey Walker, the former great middleweight champion, Tuffy Griffith, and King Levinsky. All of the bouts were held in Cleveland. In 1933, Johnny's star started to fall a bit. He'd win a few, but lose an equal amount. Patsy Perroni, from nearby Canton, Ohio, had his number, although he finally bested Loughran. In 1934, he beat Jimmy Maloney and Tommy Loughran again, but also lost five bouts; 1935 saw him with only one fight, and 1936 he was inactive. It seemed just that as fast as he had risen, he had fallen, career wise.

In 1937, though, Johnny launched a comeback and bested former light-heavy champ Bob Olin and Jimmy Delaney, before John Henry Lewis beat him. 1938–1939 saw mixed results, and in 1940 he won one fight before Tony Musto pounded him to defeat in three rounds. After that, Johnny Risko finally hung them up for good.

Johnny had 140 total bouts, with 76 being in the win column, 8 draws, 43 lost by decision, 7 lost by foul, 2 no decision, 1 no contest, and he was stopped only 3 times. He only had twenty knockout wins himself, something that probably could be factored in from his early shoulder injury. But he fought a total of 21 bouts against 13 different champions, with 8 wins and 13 losses. From 1925 until 1932, he was ranked in the top ten in the heavyweight division.

After he retired he operated a successful tavern in Cleveland, and also served in World War II. He was always a well-liked guy in Cleveland, and in and out of the ring he certainly was one of our finest ring men and popular personalities.

Johnny died in Miami, Florida, on January 13, 1953, of an apparent heart attack. He is buried in Brooklyn Heights Cemetery on Cleveland's West side.

MAX BAER DEFEATS JOHNNY RISKO ON NOVEMBER 9, 1931, TO AVENGE A DEFEAT EARLIER IN THE YEAR AT THE HANDS OF BAKER BOY.

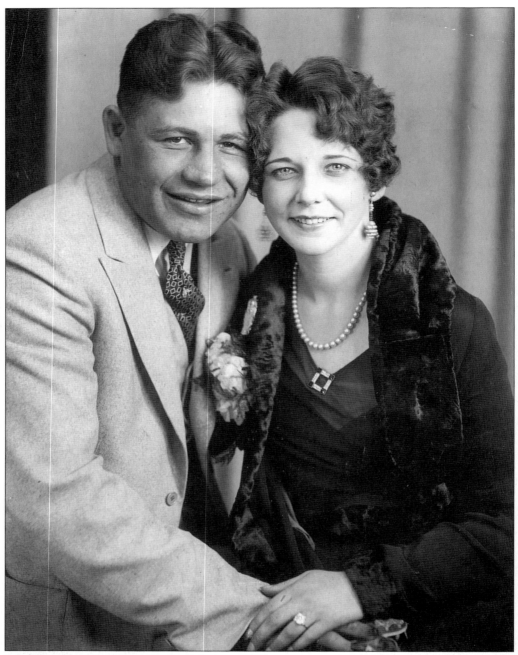

Johnny and Margaret Risko, May of 1930.

Four
PAUL PIRRONE

PAUL PIRRONE.

Not every fighter who is considered an all-time great was a world champion or even a top contender for a long time. Some are in and out of the top rankings throughout their careers. And still others guaranteed something that even the best ones couldn't—excitement—win or lose.

Paul Pirrone was a Cleveland product, who most of the time was a matchmakers dream. Although he wasn't a classic fighter, in that he didn't follow all the training rules and sometimes wasn't in the best of shape, he did guarantee slam bang thunder from either fist, and there was always the possibility that someone would hit the deck. Some people called Paul Pirrone "Poison Paul" because his fists could be lethal, to say the least. Even in the fights he lost, his opponents often felt like losers or spent time kissing the canvas.

Paul turned professional in 1928, as a lightweight, and mowed over most of his opposition, winning 12 of 13 bouts. And he continued his winning ways in 1929, only losing to former lightweight champion Jimmy Goodrich, by decision.

In 1930, things got tougher as Paul met better fighters, going only 5–3–1. He faced three former champions—defeating Jimmy Goodrich in a ten-round decision, losing another decision to Jackie Fields, and managing a draw against Tommy Freeman—while losing decisions to Sammy Baker and Bucky Lawless.

1931 saw Paul moving up in weight, finally cracking the world ratings as a middleweight. He lost to former champs Young Corbett, Gorilla Jones, and Lou Brouillard, but acquitted himself well enough to impress the people who ranked fighters. Even a kayo loss to Brouillard in Boston, in June, did not stop his rise and value to promoters.

In 1932 and 1933, he met with mixed results against mostly ranked fighters. But he fell out of the ratings and was stopped five times, including kayo defeats against Sammy Slaughter twice, Ben Jeby twice, plus losing to former champion Teddy Yarosz over ten rounds.

Things looked a little bleak for Paul as he was losing as much as he was winning, but his manager, Eddie Mead, gave him chance after chance to right the ship. Every time it seemed it was almost time to hang them up for good, Paul would beg Eddie to get him one more fight, or give him one more chance. In 1934, he ripped off a series of wins against the likes of former champion Ken Overlin, whom he defeated twice, Alabama Kid, and Bucky Lawless. Later that year saw the most exciting and important wins of his Paul's boxing life, both over former middleweight champion, the great Mickey Walker. In November he won a decision in Walker's hometown of Philadelphia, and then he flattened him in eleven rounds on December 3rd, again in Philly, the first time the great Walker had ever been counted out for the big ten count.

Paul finished up the year a week later with a decision win over tough Lou Halper, and found himself ranked the second best middleweight in the world by Ring Magazine. Only Teddy Yarosz was ahead of him, behind champion Marcel Thil.

Paul was staying in shape and fighting often now, and appeared on the cover of Ring Magazine in the March 1935 issue, something not many Clevelanders could ever brag about. In 1935, Paul had 13 bouts and lost 4 of them, but managed to kayo seven of the men he fought. He split decision wins with another former champ, Eddie Babe Risko, lost to former champ Vince Dundee, and was stopped by Frankie Battaglia.

In 1936, things started to slip a bit as he was stopped three times, including a very bad two-round kayo to former middleweight champion Fred Apostoli. This year was supposed to be the one that Paul really made his mark, but it did not turn out that way.

In 1937 and 1938, it appeared all the ring wars, and maybe skipping proper training, had caught up with Paul, and he lost six of eleven contests, and was stopped five times! He wisely hung them up for good, and retired to work for a large plumbing contractor.

When talking to the fans who saw Paul fight the one thing they always mention is how exciting his fights were, and how many times he appeared on the famous Cleveland News Toyshop Fund Shows, held every December.

Paul went to the wars 119 times, and managed 21 fights against 15 former world champions, claiming victories over four of them, with a draw against the fifth one, and six wins total. His won-loss record of 82 wins, 34 losses, and 3 draws, included 53 kayo wins, and 16 kayo defeats.

But it also included a million and one thrills for those who were privileged to see him in action.

I only got to meet Paul one time, during his retirement years, although I had the pleasure of meeting and getting to know his youngest son, Eugene. And I also had the honor of being given his boxing trunks by Gene and other family members, some years ago. Paul passed away on July 10, 1988.

A VERY
YOUNG
PAUL
PIRRONE.

PAUL AND HIS MANAGER, EDDIE MEAD, 1934.

PAUL PIRRONE WORKS ON THE BAG.

PAUL FLOORS ERIC SEELIG DURING ONE OF HIS
MANY CLEVELAND NEWS TOYSHOP FUND SHOWS.

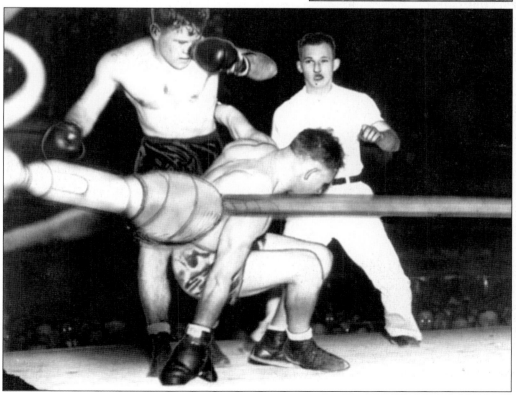

"POISON PAUL" WORKING OUT IN 1934.

Five
GEORGE PACE

GEORGE PACE.

It's funny how some fighters never seem to get their just recognition. When Cleveland's greatest fighters are mentioned, or when a list of world champions is made, mostly you hear about Johnny Kilbane and Joey Maxim. And today with so many different weight classes and different alphabet organizations, young fans think it has always been always that way, and I suppose they also think that having a piece of the title is unique.

But back in the days when George Turner Pace fought, there were split titles also with the NBA (National Boxing Association) and New York State often dividing recognition. And later on, even the British Boxing Board of Control sometimes listed its own champion. The big difference was that there were only eight weight classes then!

George Pace was indeed a world champion, even if not for long, and even if not universally recognized. If he can't get his just due for that, it won't be my fault because I try to make people aware of the fact as often as possible.

George Pace was born on February 2, 1915, in Macon County, Alabama. And his entrance into this world was not your standard one. He was born with cataracts over both eyes, and other health problems, much of which he felt came in part because his mother was very sickly. He and his seven brothers and sisters lost their mother when George was only five. Their father, James Pace Sr., lived to be 86 years old, and was married three times. But George was basically raised by his grandmother, Emmaline Pace, who was part Cherokee and part African American.

The Pace family moved north early on, seeking work, and George was raised mainly in a West side neighborhood that had few black families. Times were not easy, to say the least, so George and his brothers learned to fight, and eventually one of his cousins took him down to a local gym to teach him how to defend himself.

While at the gym, he came under the watchful eye of Phil Goldstein, an ex-fighter, trainer, and local fight personality. Phil eventually entered George in the local Golden Gloves as a 105-pound novice. George had some success, but no titles until he finally won the City Golden Gloves in 1933, as a bantamweight. He qualified for the National AAU tournament held in Boston, but an unfortunate training accident left him with a broken left hand, something that was to bother him his whole career. Despite his busted mitt, George won two bouts before being ousted by a very controversial split decision.

In 1934, after winning 63 of 71 amateur fights, George Pace turned pro, but he did not have a lot of early success. He seemed to be matched with much tougher and more experienced fighters. And in the years 1934–1936, he lost to KO Morgan, Ross Fields, Mose Butch, and Indian Quintana, while knocking out Nat Litfin in one round, but getting stopped by Lloyd Pine in three rounds in Akron. Many of his early bouts were held in Pittsburgh on the undercard of Fritzie Zivic fights.

Throughout 1936, George's record was not much to write home about, and he was getting discouraged. But he changed managers from Jimmy White to Tom Stanley, and he seemed to have a new outlook on things.

With better management, and better training, he began to have a fresh approach to things, and it showed up in his success in the ring. 1937 and 1938 were going to be quite fruitful for George, and he started to win, with many of the fights taking place in Toronto, Canada, where he became a crowd favorite. It seemed almost like a miracle that a guy who got thrown in over his head so early, and took some pastings, not to mention did not have much luck, could suddenly turn things around. But in 1937 he won seven of nine fights, and in 1938, won all eight of his contests. He defeated Angelo Callura, Indian Quintana, Katzumi Morioka, Baby Yack, Henry Hook, and Johnny Gaudes, just to name a few.

Nineteen thirty-nine saw George defeat Henry Hook again, this time in Cleveland, and then Sammy Stewart in Columbus, Ohio. All totaled, the years 1937–39 produced a fine record of 19 wins, and only 2 defeats; at year's end he was ranked near the top of the bantamweight ratings by the "Bible of Boxing," *Ring Magazine*.

GEORGE PACE AND SUGAR RAY ROBINSON IN NEW YORK CITY, 1940.

Meanwhile, the world champion was Sixto Escobar of Puerto Rico, and he was having weight problems. They tried to match George with him several times, but Escobar was reluctant, so eventually the NBA stripped him of his title and awarded it to George. The reasoning behind this was simple: George was top ranked, Escobar would not defend against him, and he had defeated several fighters who had beaten Escobar, most notably Henry Hook—whom he defeated twice—and Indian Quintana.

Why Cleveland has never fully recognized George Pace as a world champion is beyond me. A photo showing Tris Speaker (Former Cleveland Indians baseball great) and the great John Kilbane crowning George, and the certificate from the NBA (on the following page), prove it.

Finally, as the politics of boxing worked, they decided the best money match was to pit George against the New York State representative, Lou Salica, for the universal title. They met in Toronto over fifteen rounds on March 4, 1940, but at the end nothing was proved, it was called a draw. George held his piece, Salica his, and George stayed active by fighting two more times, winning both. He defeated Pablo Dano in New York, and knocked out Lawrence Gunn in Baltimore in the first stanza.

Finally on September 24, 1940, Salica and George met in a rematch, this time in New York, and Lou was victorious after fifteen hard fought rounds. He won all the marbles. George went back home to hopefully continue on with his career, and get another shot at the title.

George fought on after the Salica loss, but won only five of nine with one draw and no talk of title shots. In spite of his health problems, he was declared fit enough to enlist in the Army in World War II, served honorably in Europe, and was discharged in 1945, as a Corporal.

Although George did have one fight during the time he was in the Army, a ten-round loss to Al Reasoner in 1943, his heart was no longer in it. When he got discharged in 1945, the mounting health problems seemed to plague him more and more, so he hung them up for good. His final record was 32–13–2.

What always amazed me about George was his courage and faith. He had severe asthma, which often drove him to Arizona in the winter. He had so many operations that he lost count. At one time he said he had at least 17 operations on his eyes, his nose, his sinus cavity, his stomach, etc.

Married twice, with four children, George had many friends and I count myself as one of them. He and I kept in touch often, even when he was in Arizona, and as I said I admired him greatly. Often, I would hear from George and he would be in the VA hospital with more lung problems. He took up the hobby of watercolor painting and would give his artwork to doctors and nurses and children. I am proud to have a couple Pace originals in my house.

When his heart gave out and he passed away on July 20, 1984, I lost a dear friend, and Cleveland lost a great champion.

TRAINER JOHNNY PAPKE, MANAGER TOM STANLEY AND GEORGE PACE IN CORNER DURING HIS 1939 PUBLIC HALL WIN OVER JIMMY WEBSTER BY NINTH ROUND KNOCKOUT.

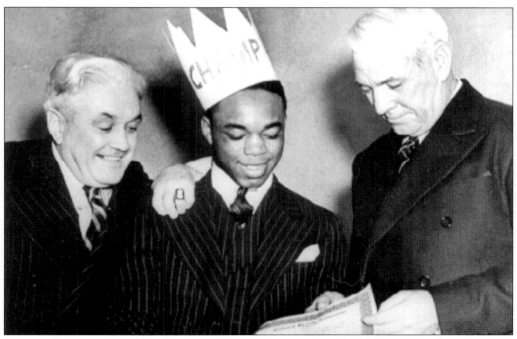

JOHNNY KILBANE (LEFT), GEORGE AND TRIS SPEAKER AS THE NBA PRESENTS GEORGE WITH THE CERTIFICATE NAMING HIM NBA BANTAMWEIGHT CHAMP, NOVEMBER 1939.

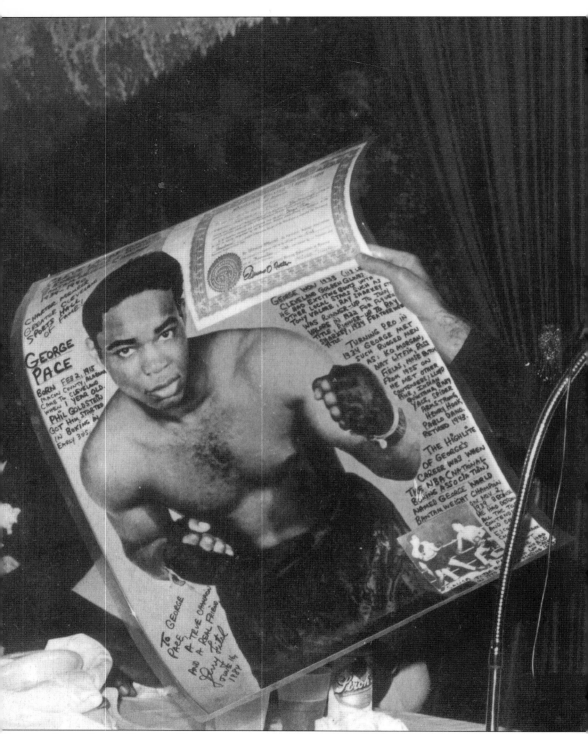

OHIO STATE FORMER BOXERS AND ASSOCIATES HONOR GEORGE PACE AT THEIR 12TH
ANNUAL DINNER, JUNE 6, 1984, WITH AUTHOR JERRY FITCH PRESENTING THE AWARD.

48

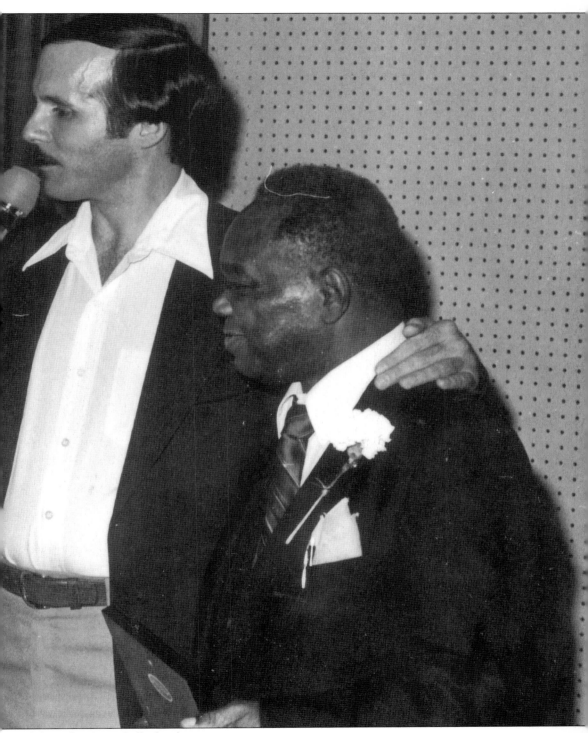

(Photo by Terry Gallagher.)

National Boxing Association
of America

Know All Men by These Presents:

WHEREAS GEORGIE PACE

having won the title of Champion Boxer of the World in the _Bantam weight_ Class, in open competition, under the rules of the NATIONAL BOXING ASSOCIATION OF AMERICA.

It is therefore declared and published, that the said _Georgie Pace_ , be and is hereby recognized by the NATIONAL BOXING ASSOCIATION OF AMERICA, as the _Bantam_ weight Champion Boxer of the World and is awarded the NATIONAL BOXING ASSOCIATION Belt.

In Witness Whereof, the NATIONAL BOXING ASSOCIATION has caused its corporate seal to be affixed on this _2nd_ day of _November_ , 19_39_ , and signed by its President and attested by its Secretary.

ATTEST: **National Boxing Association of America**

Edward C. Foster _Harvey Fuller_

Secretary President

THE CERTIFICATE GIVEN TO GEORGE PACE ON NOVEMBER 2, 1939, PROCLAIMING HIM NBA BANTAMWEIGHT CHAMPION.

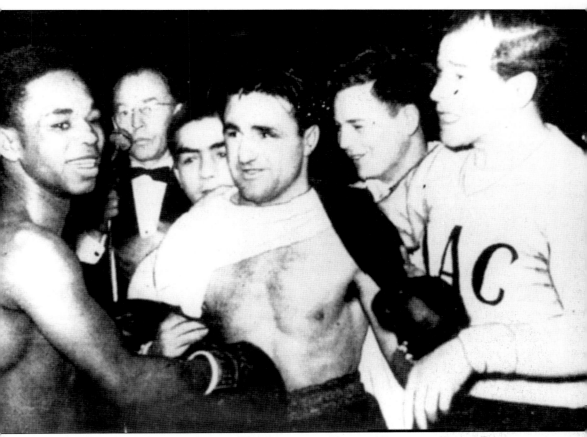

GEORGE AND LOU SALICA SHAKE HANDS AFTER THEIR 15-ROUND TITLE DRAW IN TORONTO.

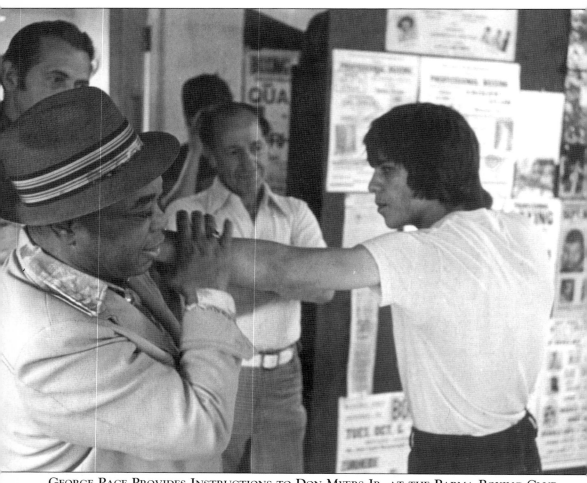

GEORGE PACE PROVIDES INSTRUCTIONS TO DON MYERS JR. AT THE PARMA BOXING CLUB 1980, AS TROY BELLINI LOOKS ON. (Photo by Terry Gallagher.)

Six
LLOYD MARSHALL

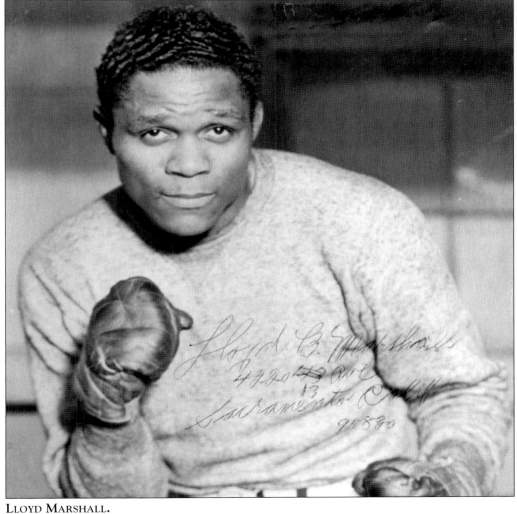

LLOYD MARSHALL.

Unless you are an avid boxing fan who studied the history of it or were around during the era that Lloyd Marshall fought, you probably do not know much about him. And yet he compiled a remarkable ring record against some of the finest middleweights, light-heavyweights and even heavyweights in his or any era.

Lloyd Marshall was born in Madison County, Georgia, on June 4, 1914, and he came to Cleveland at a very young age. He lived in a neighborhood that was racially mixed and very tough on Cleveland's East side. And good fighters on the streets often turned to the ring during the difficult days of the 1930s. Lloyd was no different, and he ended up winning the Cleveland Golden Gloves in 1934 and 1935. He started boxing at 17, and by the time he was done with his amateur career he had 219 fights with only 17 losses.

When it came time to turning pro, Lloyd found the offerings locally not that great. So he followed a baseball player, Frank Doljack, who had been with Detroit and Cleveland and was playing in California in the Coast League. He urged Lloyd to go west and set him up with a family, the J.E. Edwards family, where he lived for five years. Without their generosity Lloyd would have never made it.

When he turned pro in 1937, he did not waste any time fighting patsies, and he soon became a big favorite in San Francisco. By 1939, he had already met five world champions in Ken Overlin, Ceferino Garcia, Babe Risko, Teddy Yarosz and Lou Brouillard, and had defeated four of them. Only Garcia seemed to have his number at that stage of his career.

It may not ever really be known how good Lloyd Marshall was, for many stories came out of his early days saying his hands were tied, he was too good for his own good , and was not allowed to win.

By 1942, Lloyd had a record of 29–6–2, with 17 knockouts, and had defeated four world champions, as well as the wonderful Charley Burley. He was stopped just once—by Ceferino Garcia.

In 1943, he won three straight on the coast and then headed back to Cleveland for the first time since his amateur days. At the time he was ranked number one light-heavyweight in the world.

Larry Atkins, who along with Bob Brickman had staged some marvelous fights in Cleveland, brought him back. Atkins, whose real name was Nussbaum, once worked with Jack Dempsey on his comeback trail. But along with his money man, Brickman, staged some of the best fights in the world during the 40s, 50s, and even the 60s right here in Cleveland, Ohio, mostly at the old Cleveland Arena.

He talked about bringing Lloyd back in a *Plain Dealer* story in 1979. "He was already in his late 30's [Lloyd was actually only 29] when I brought him to Cleveland. I made an honest fighter out of him, I sat him down on a bench in the Terminal Tower when he came in and told him if he fought here he'd have to fight honest," recalled Atkins in the article.

Well, what was meant by those comments, I don't know, because it is not like Lloyd had a bad record. I do know he only fought one fight in New York his entire career, and it turned out to be a humdrum affair because of his opponent's awkward style. They never asked him back, and nobody wanted to fight him in the boxing Mecca, as New York was often called.

Atkins went on in the article to say, "He was a beautiful fighter. He'd hold his hands at his side and he could counter punch better than anyone who ever lived. I started him out against Ezzard Charles, a heavyweight, and Lloyd knocked him out. Then he gave Jake LaMotta the worst beating you ever saw. He knocked down Jimmy Bivins and he beat Anton Christoforidis when Christo was really good."

In reference to the Bivins bout it can be safely said that Lloyd did give Jimmy a hell of a fight for a while and did have him down, but then he too got knocked down three times and finally stopped for good in the 13th round. This was in his challenge for Jimmy's "Duration" light-heavy honors before 18,000 fans in rain-soaked Cleveland Stadium, on June 8, 1943.

Lloyd also defeated Joey Maxim and Nate Bolden in ten rounds in Cleveland, and continued on his winning ways through all of 1944 and into the start of 1945. Then came the Archie Moore bouts.

LLOYD AND BASEBALL PLAYER FRANK DOLJACK, WHO GOT LLOYD TO MOVE TO CALIFORNIA TO START HIS CAREER.

There have been many stories about the contests involving Lloyd Marshall and Archie Moore. In Peter Heller's book *In This Corner*, Archie Moore is quoted as saying, "Lloyd Marshall rated number one in the light-heavyweights, dangerous puncher, break your head with a punch with either hand, shifty fighter. Lloyd knocked me down four times. I got up and cut Lloyd dusty, knocked him down three times. I cut Lloyd seventeen times, over the eye, under the eye, around the nose, around the mouth, and he was a bloodied, bleeding hulk, and I could have knocked him out in the tenth round. I hit him and he stumbled into the ropes and I stepped back. The crowd rose to its feet and said, What a sportsman!

"I didn't hit him hard no more. The fight ended and Marshall collapsed on his stool. He lost by decision. People said, 'This man is too much!' Then I knocked Lloyd out in Cleveland in the tenth round, because I remembered how he knocked a boy out named Harvey Massey here in San Diego. He had beaten Massey to a crisp and in the ninth round the referee walked up and said, 'You guys better mix it up a little more,' and Lloyd walked out honest to goodness, and leveled on poor Harvey Massey and left Harvey laying flat on his back.

"I walked back to the dressing where Lloyd was, and I never met Lloyd before, and I said to Lloyd, 'You didn't have to knock the man out. You had him beat. You're a professional fighter. Both you guys are pros. The fight was a good fight, you didn't have to knock him out.'

"He said, 'What's it to you?' I said, 'Nothing to me, we'll fight one day.' He said, 'That's all right with me.' Now the first fight I am thinking about making money so I don't knock him out, because I can get a rematch with him in his hometown of Cleveland, in a bigger place, although we sold out in Baltimore. When I fought him in Cleveland, in the tenth round, just as he did to Harvey Massey, I did him exactly the same way, and walked away from him. I think about those things."

In all honesty the only time I ever saw Lloyd Marshall in action was on film, and he was in the later stages of his career. In one 1946 film, he knocks down Ezzard Charles but gets stopped in the sixth round himself. In a second film he is supposed to be an over the hill opponent for Freddie Mills, in London, England, on June 3, 1947. Surprise, surprise—the over the hill opponent takes Mills apart in five rounds.

But like a lot of things during those days, Lloyd got his biggest payday—$27,000—and Mills got a return title match with Gus Lesnevich and won the light-heavy crown.

They always talked about how Muhammad Ali carried his hands low at his sides at times. Well, he had nothing on Lloyd, he was years ahead of Ali and that is the way he fought. He would roll his shoulders, slip punches and launch his counter attack. One can only wonder what he would do today, but I'd safely say he would be a champion easily.

From 1948 on, after the Mills bout, Lloyd had mixed results, often going into the other guy's backyard, or in some cases country. He fought in England and Germany and Hawaii and met the best around. But he wasn't winning like he had earlier, and guys like Bob Murphy, Don Cockell, Bobo Olson, and Harry Kid Matthews all stopped him in his last year, 1951.

His wife Macia (Mazie) called the commission and pleaded with them to not let him fight again. He was almost 38 years old and had been in the ring wars too long she felt. Lloyd said, "Mazie didn't want me to fight any more. She went to the commission and the next thing you know I was through at 38! God Bless her for then, now and forever."

Lloyd and Mazie were married well over 50 years. Lloyd was entered into various California and Cleveland Sports Hall of Fames and in 1996 entered into The World Boxing Hall of Fame in Los Angeles.

I finally got to meet Lloyd in 1983, when I talked him into coming back to Cleveland for a visit. He rode a Greyhound bus all the way in from Sacramento to Cleveland and his old foe Jimmy Bivins was at the depot to greet him. During his stay here, he visited his mother and also many boxing friends. He was interviewed for an article in the *Plain Dealer*, was taken around to old haunts by ex fighters and friends like Georgie Pace, Chuck Watkins, and Jimmy Bivins. We had a get together with other fighters at the Parma Boxing Club, and he and Jimmy Bivins had a sort of forty-year reunion for their 1943 Cleveland Stadium battle. They hammed it up in the

ring and you could see the genuine respect they had for each other. I never saw Lloyd again after he left to go back to California.

Lloyd left this good Earth on August 6, 1997, leaving behind a whole lot of memories and a professional record of 92 fights, 64 wins, 24 losses, 4 draws, with 32 kayo wins. He met 12 world champions and defeated 9 of them, and overall appeared in the ring with a champion, or former champion, 17 times, with 9 of them being in the win column.

Along with the names Jimmy Bivins, Johnny Kilbane, and others I write about in this book, Lloyd without a doubt is one of Cleveland's Greatest Fighters of All Time.

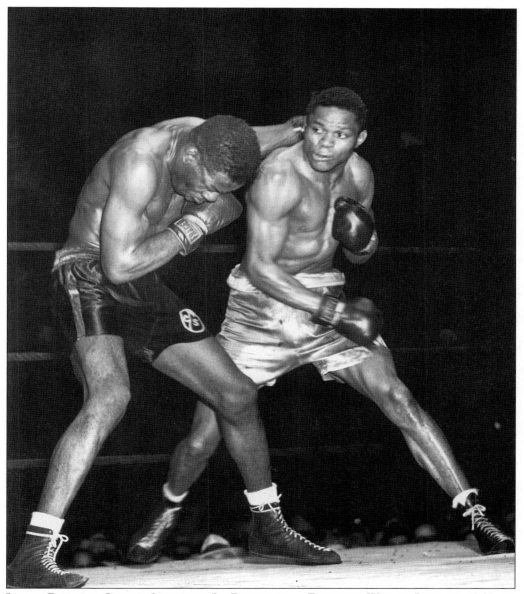

LLOYD BATTERS CURTIS SHEPPARD IN ROUTE TO A DECISION WIN IN JULY OF 1943, IN CLEVELAND.

LLOYD MARSHALL SPARS AS HE GETS READY FOR HIS BOUT AGAINST CURTIS "HATCHETMAN" SHEPPARD, JULY OF 1943.

LLOYD JARS FREDDIE MILLS IN THE FIRST ROUND WITH A LEFT HOOK.

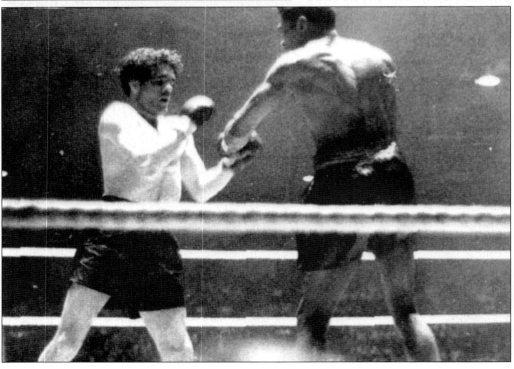

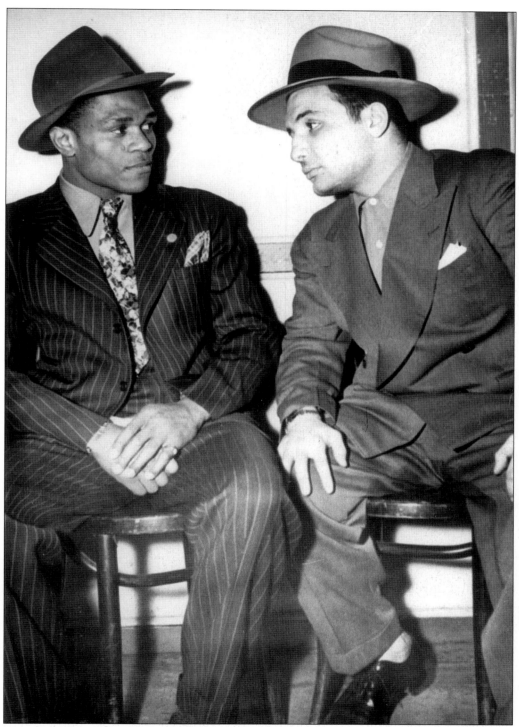

Lloyd Marshall and Jake LaMotta chat before their April 21, 1944, Cleveland Bout, won by Marshall by lopsided decision.

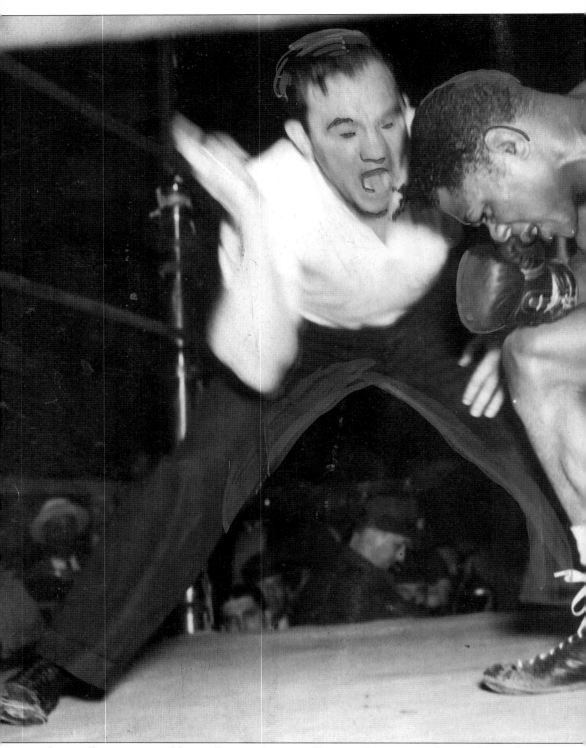

LLOYD DOWN IN THE NINTH ROUND AGAINST FELLOW CLEVELAND GREAT, JIMMY BIVINS,

AS REFEREE JACKIE DAVIS PICKS UP THE COUNT. (Photo by Cragg.)

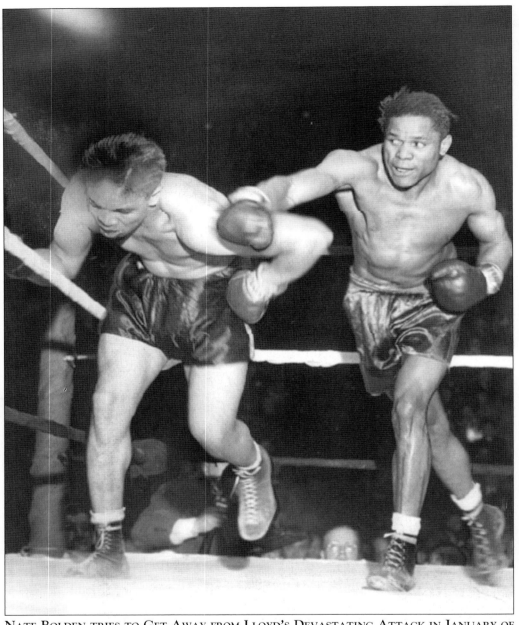

NATE BOLDEN TRIES TO GET AWAY FROM LLOYD'S DEVASTATING ATTACK IN JANUARY OF 1944, IN CLEVELAND.

Lloyd's wife, mazie, Checks His Muscles.

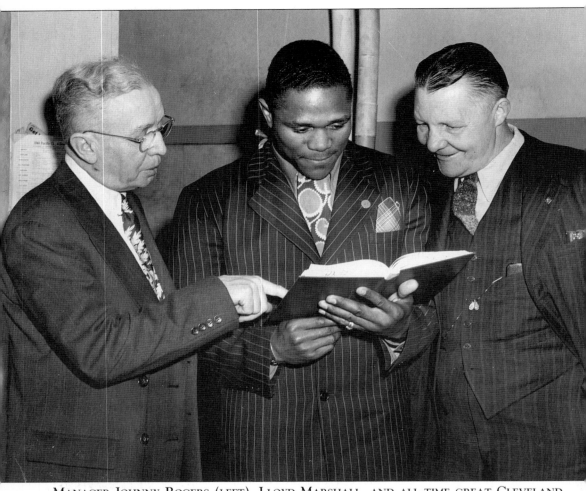

MANAGER JOHNNY ROGERS (LEFT), LLOYD MARSHALL, AND ALL-TIME GREAT CLEVELAND TRAINER, JOHNNY PAPKE, 1943.

LLOYD MARSHALL AND HIS MANAGER, JOHNNY ROGERS.

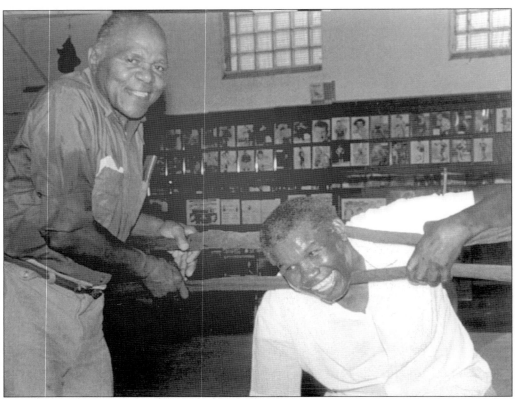

LLOYDE GETS EVEN WITH JIMMY BIVINS, 40 YEARS AFTER THEIR EPIC CLEVELAND STADIUM MATCH, WHICH BIVINS WON WITH A 13-ROUND KNOCKOUT. (Photo by Terry Gallagher.)

Seven
JIMMY BIVINS

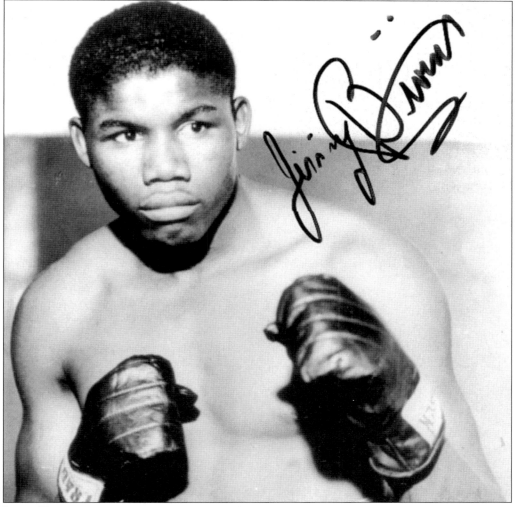

JIMMY BIVINS.

When you have known someone for close to 30 years, maybe you tend to take things for granted. I had always looked at Jimmy as a larger than life character, because of his exploits in the ring. He was a friend, not only to me, but also to my family. And he was a famous fighter, a real famous fighter. And as I learned about him and wrote about him, I admired him more and more.

Sometimes all of us get wrapped up in our own lives, so busy, that time goes by and we don't realize that we have lost contact with others for longer periods of time than we imagine. I had not been in touch with Jimmy Bivins very much in 1997 and 1998. I had tried to call, usually got no answer, or sent a note or letter to the address I was given, and quite frankly none of my letters were returned to me. But over the years, if I happened to send a copy of a story or something of interest to Jimmy, he would call me up and thank me and we would discuss it.

The thing that really started to make me wonder, was when an article in the *Plain Dealer* mentioned he was residing in South Carolina. Jimmy had always told me he would never move, that he had offers to live on the west coast and other places when he was fighting, and even though he fought everywhere, Cleveland had been his home since he was a little boy, and he had no intentions of leaving, even after his wife passed away in 1995.

But when I picked up the *Plain Dealer* on April 8, 1998, I was shocked beyond belief as the front page had a photo of Jimmy, and stated he was found injured and ill-fed in the attic of his daughter and son-in-law's house, weighing approximately 110 pounds.

A lot can be written about this tragedy and the court proceedings that followed, but even now Jimmy does not want to say harsh things about his daughter or what happened. I personally have a lot of thoughts and an opinion, but I will respect Jimmy's wishes and just say that what happened to Jimmy should never happen to anyone, much less a father.

And this leads to, without a doubt, Jimmy's greatest comeback of his career and his life. Often he would be counted out when he fought, as boxing fans and writers figured Jimmy's career as an important contender was over, and then he would come up with a big win, or launch a series of wins that would fool them all. Once he started to recover in the hospital and in rehab, he did indeed launch a comeback, the greatest of his life. Not only did this near tragedy put his name back in the spotlight, but it also opened up a lot of eyes not only to the sadness of the moment, but also to the fact that he was indeed a much better fighter than some people remembered.

From that point on, in the Spring of 1998, he was bestowed many honors, written about in such well known publications as *Sports Illustrated, Cleveland Magazine*, along with others lesser known, plus many boxing publications.

In 1943, Jimmy was considered the NBA (National Boxing Association) "Duration" or Wartime Champion in both the light-heavyweight and heavyweight divisions, and he was promised a belt back then by the governing body of the NBA, but it was not to be. However, due to all the publicity and a grass roots campaign by many local people, Mr. Irv Abramson, former head of the NBA, did some research and discovered that yes, indeed, the winner of the heavyweight "Duration" title between Jimmy and Tami Mauriello was supposed to be given a championship belt.

Well, in July of 1998, I personally presented Jimmy with the belt that declared him World Heavyweight Duration Champion, 1943. It was an honor that was 55 years overdue, but finally happened, much to the happiness of Jimmy and all who know and love him.

In June of 1999, Jimmy was entered into the International Boxing Hall of Fame in Canastota, New York. This was long overdue, and once again the results of many fans and friends writing letters and petitioning the Hall to wake up and see the facts. Jimmy deserved to be there: he had the credentials and had paid his dues.

Jimmy's boxing career started in the Golden Gloves like a lot of the fighters I write about in this book. He won the 1937 Novice Featherweight Championship, and eventually won the Open Division at 147 pounds in 1939, going on to the Nationals in San Francisco, where he was robbed of the championship on a very controversial decision to a fighter from Rome, New York, named Cozy Storace. *The San Francisco Chronicle* verified my opinion, saying that Bivins won the fight, at least in the eyes of most everyone but the judges.

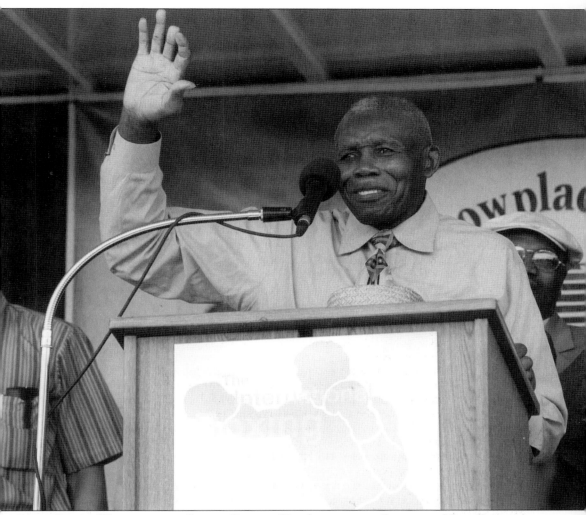

Jimmy Bivins Waves to the Crowd During His Acceptance Speech as He is Entered into the International Boxing Hall of Fame, June 13, 1999. (Photo by Pat Orr.)

Jimmy decided to turn pro in 1940, upon the advice of his father and some other rather famous people. It is said that the great Olympic Champ Jessie Owens even gave his strong endorsement to the matter.

Much has been written about Jimmy's career, and I have covered it over and over in most every major boxing publication in the world at one time or another, but it still never ceases to amaze me what I find in my research and what I learn when talking to people.

The fact that he won 86 of 112 fights and defeated 8 world champions is pretty much a well-known fact. But how good he really was is often lost with time, and some of the other names on his boxing resume are not truly known by younger fans who are not avid boxing buffs or historians.

The names Archie Moore, Joey Maxim, Jersey Joe Walcott, Joe Louis, and Ezzard Charles are known by most everyone. However, some of the others like Curtis Sheppard, Charley Burley, Bob Pastor, Leonard Morrow, Clarence Henry, Wes Bascom, Coley Wallace, and Lee Q Murray, just to name a few, were others Jimmy defeated, even at the end of his career. And they were contenders also. It seems Jimmy was fighting mostly good fighters all the time.

In this modern boxing era, fighters get a couple fights and the next thing you know, they are fighting for one of the numerous titles created by the alphabet groups that have all but ruined boxing. It was not like that when Jimmy fought; a boxer could fight for many years with many fights, and not even think about getting a shot at any title.

Jimmy got into serious competition in his first year as a pro, and wins against Charley Burley, Nate Bolden, and Anton Christoforidis dot his win column to attest to where he was heading. Only a December loss to Christoforidis ruined his perfect record as he went 19–1 and landed in the top ten of the middleweight division as seen by the "Bible of Boxing," Ring Magazine, and its guru editor and founder, Nat Fleischer.

Jimmy moved up in weight, but he often fought men much heavier and taller than him. When he lost to Lem Franklin by TKO in nine rounds in July of 1941, he was giving away over 25 pounds. As his career headed toward 1942, he was winning most of his bouts regardless of the size or excellence of his opponents, which included champions, former champions or champions to be, such as Anton Christoforidis, Teddy Yarosz, and Billy Soose.

On March 11, 1942, Jimmy had perhaps one of the more controversial encounters of his career, when he was matched with the World Light-Heavyweight Champion, Gus Lesnevich, in a non-title affair at the old Cleveland Arena on Euclid Avenue.

It seems that there was some trickery involved according to newspaper reports, and when Bivins thrashed Gus over ten rounds—flooring him and leaving him bloody—most people felt Jimmy would now get a much deserved title shot at the champion, having proved he was more than capable of handling a champion such as Lesnevich.

But the weights were established so that Jimmy had to agree to come in over the title limit of 175 pounds, and when the weigh-in came about, he was one-quarter of a pound under the limit. Well, Lesnevich's management would not go for it, and made Jimmy drink enough water that he weighed in at 176 and could not lay claim to the title no matter what happened.

After the one-sided win by Bivins, Co-Manager Lew Diamond was heard saying, "Mr. Bivins was the best man tonight, but his name is crossed clean out of our book." To most people this was just sour grapes. Regardless of the attempt to weigh-in under the limit, Jimmy proved he belonged at the top of the light-heavy class, and he so thoroughly outclassed Lesnevich it was a travesty that he never did get a title shot at him.

But this was to prove to be Jimmy's legacy throughout his career. He would beat so many good fighters and be so highly rated, and yet never get a title shot. In December of 1942, he was ranked the number one contender in both the light-heavy and heavyweight divisions, something that had never happened before and has never happened since, and still he never got as much as a smell of a title.

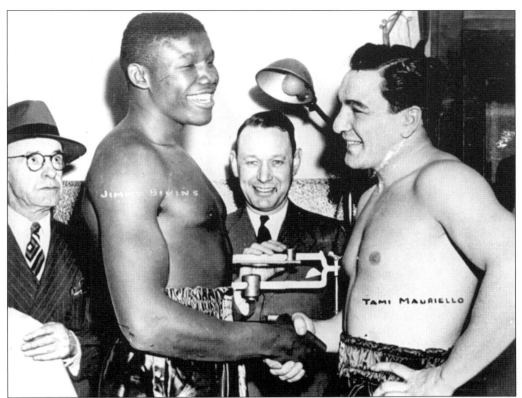

JIMMY BIVINS AND TAMI MAURIELLO WEIGH-IN FOR THEIR "DURATION" HEAVYWEIGHT TITLE BOUT ON MARCH 12, 1943, AT MADISON SQUARE GARDEN.

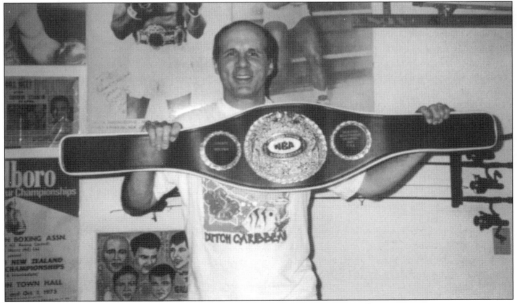

AUTHOR JERRY FITCH WITH THE NBA BELT HE PRESENTED TO JIMMY.

Jimmy no doubt was not an unbeatable fighter, especially from 1946 on, but even then he still managed to hold his own against many contenders, and was rated in the top ten as late as 1953. But the real crime is exposed when you check out Jimmy's career from 1940–1945, during which he recorded a record of 48–5–1, with 16 kayo wins, and defeated eight world champions, including knocking out Archie Moore, and knocking down Ezzard Charles four times in a one-sided affair in 1943.

During one stretch from June of 1942 to February of 1946, he was a remarkable 26–0–1, with the one draw being against former light-heavy champ Melio Bettina. During that streak he bested Joey Maxim, Tami Mauriello (twice), Bob Pastor, Ezzard Charles, Anton Christoforidis, Lloyd Marshall, Melio Bettina, Lee Q Murray, Curtis Sheppard, and Archie Moore, among others.

Jimmy was always a man of integrity and stubbornness, and he would never bow to the powers-that-be, so he did not get what he justly deserved at the time. When approached by the "boys" in New York to play ball, his response was swift and to the point: "I am a fighter, not a ballplayer."

JIMMY BIVINS STANDS BY HIS HALL OF FAME PLAQUE, JUNE 13, 1999. (Photo by Pat Orr.)

His integrity is what kept him from a title shot and the real big paydays, and when he got $40,000 to fight Joe Louis in 1951, it represented his largest purse ever. Still, he was a frugal man, he saved and he worked, and he bought a house for his parents and himself.

Jimmy won the "Duration" titles in 1943, when he first defeated future heavyweight champion Ezzard Charles over ten rounds on January 7, 1943, in Cleveland, and then walked off with a 15 rounder against former NBA light-heavy champ Anton Christoforidis on February 23, 1943, also in Cleveland.

Much has been written about his bout with Tami Mauriello in Madison Square Garden on March 12, 1943, for the "Duration" Heavyweight title; how he floored Tami, almost stopped him, and made Frank Sinatra cry. But the bottom line is that Jimmy won, won big. But when Joe Louis fought and beat Billy Conn, it was Tami, when he got out of the Army, rather than Jimmy, who got a shot at the title… same old story.

Still, as life has gone on, at least Jimmy slowly but surely has gotten the proper recognition, even if it has taken what seems like forever, and in some cases, a near tragedy.

Among his honors are being entered into two different Cleveland sports halls of fame, the Canadian Boxing Hall of Fame, being honored twice by the Rochester Boxing Hall of Fame in New York, and in 1994, being entered into the World Boxing Hall of Fame in Los Angeles.

The years 1998 and 1999 saw him get his long overdue championship belt, and an entrance into the International Boxing Hall of Fame. But most importantly, his most recent victory was in life itself. Those of us who have known Jimmy and admired him are most pleased with this victory over all the others.

Jimmy and faith are two tough opponents to overcome.

JIMMY WALKS AWAY AFTER STOPPING JOEY MAXIM , AS A 147-POUND AMATEUR—THIS WAS A RARE FEAT!

73

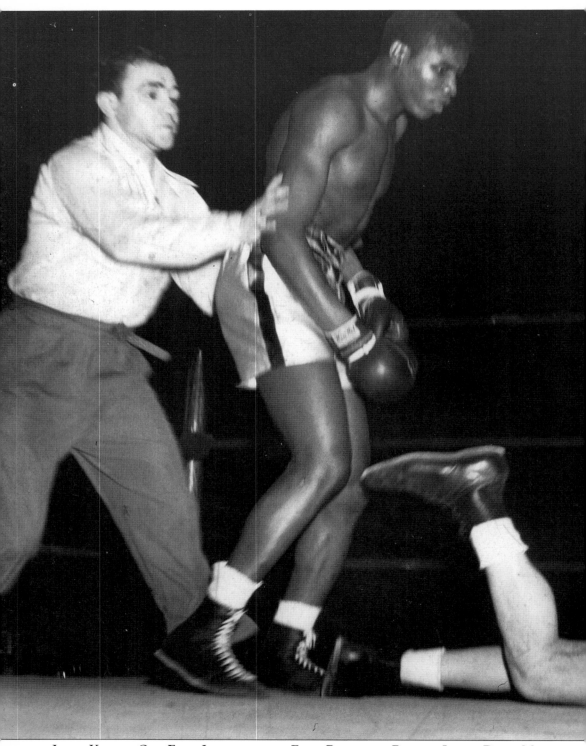

Jimmy Knocks Out Enzo Ianozzi in the First Round, as Referee Jackie Davis Moves

In to Push Bivins to a Neutral Corner, April 25, 1940.

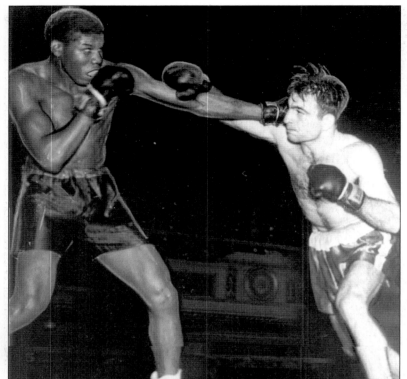

JIMMY AND
ANTON
CHRISTOFORIDIS
IN ONE OF THEIR
THREE 1940S
BATTLES.

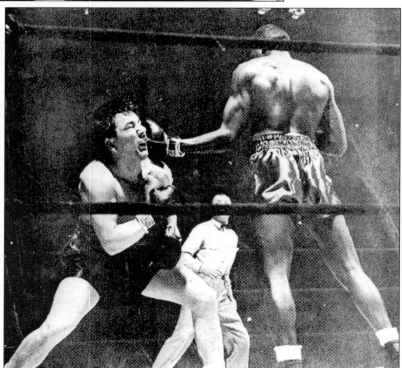

BIVINS-
MAURIELLO,
MARCH 12,
1943.

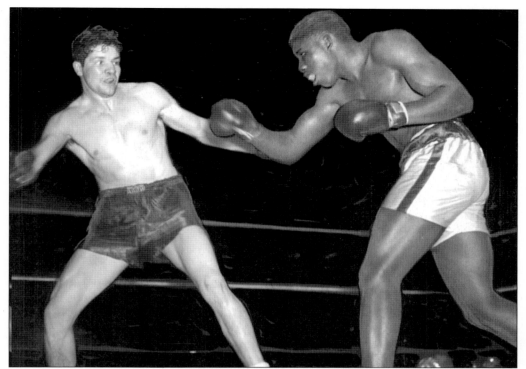

JIMMY WALTZED TO A DECISION OVER FORMER MIDDLEWEIGHT KINGPIN BILLY SOOSE,
JANUARY 13, 1942.

FORMER MIDDLEWEIGHT CHAMP BILLY SOOSE AND OLD FOE JIMMY BIVINS HAM IT UP IN
ROCHESTER, NEW YORK, MAY OF 1985. (Photo by Tony Liccione.) Soose retired after their
January, 1942 bout, saying that when Bivins hit him in the temple he felt like he had been shot.

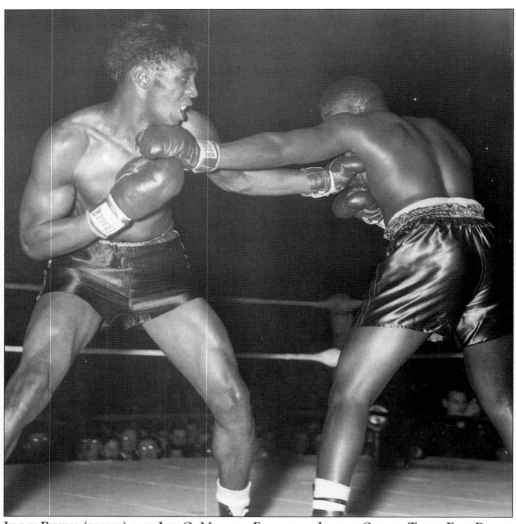

JIMMY BIVINS (RIGHT) AND LEE Q. MURRAY EXCHANGE JABS IN ONE OF THEIR FIVE BOUTS
(BIVINS WON THIS ONE IN A TEN-ROUND DECISION IN CLEVELAND), DECEMBER 1, 1943.

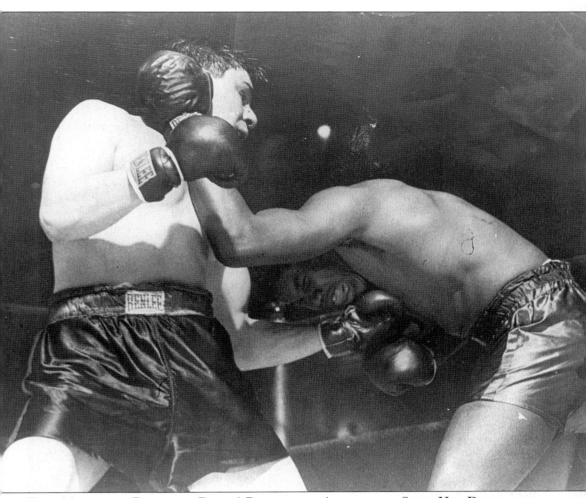

Tami Mauriello Digs into Bivins' Body in an Attempt to Slow Him Down, but Jimmy went on to Win the "Duration" Heavyweight Title, March 12, 1943, in New York City.

REFEREE MAGAZINE, MARCH 13, 1948.

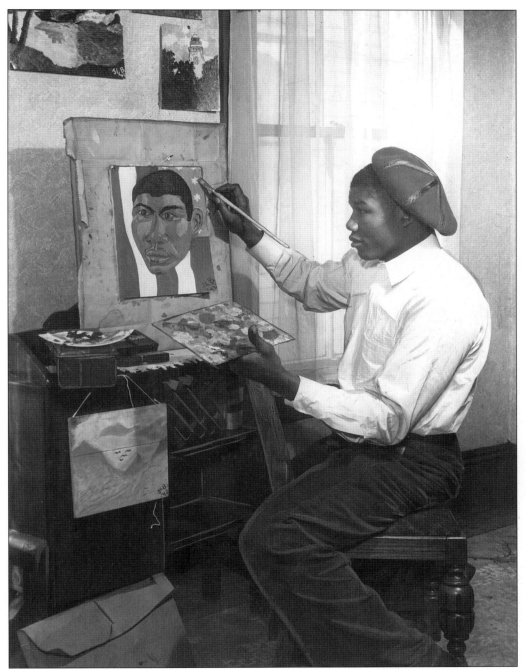

JIMMY EVEN TRIED HIS HAND AT PAINTING AS HE DOES A SELF-PORTRAIT IN 1943.

Nineteen-fifty's heavyweight contender Coley Wallace is perhaps most famous for defeating Rocky Marciano in the amateurs, and playing Joe Louis in *The Joe Louis Story*. But there was a time when he was a rising heavyweight star, and when he and Jimmy met on September 19, 1952, at St. Nick's Arena, in New York, Coley was supposed to be on the way up and Jimmy on the way down. They fought for eight rounds, and Jimmy and his corner thought he was winning (it turned out he was behind on the score cards). Coley had a careless habit, according to Jimmy, of hitching up his loose fighting trunks, and Jimmy took notice of that. When the next round started, Jimmy moved over quickly, and when Coley proceeded to hitch them up again, he hit him with a straight right hand. Down went Coley for the count, 17 seconds into the ninth round of the nationally televised bout.

In a phone conversation a few years ago, Coley went on to tell me how Jimmy "suckered" him in for the knockout during their fight, and what a great fighter Jimmy was. "I thought he was well over the hill, but he showed me a thing or two," Coley reflected.

There is more to the story, however. Years later, an impostor was passing himself off as Jimmy in Rosedale, New York. He worked on the docks, and had Jimmy's career down to all the important facts. Only he wasn't Jimmy, and most everyone knew it except for the poor guy who got suckered in at *Ring Magazine*, who actually managed to write a story on the fake Jimmy Bivins. Coley Wallace knew Jimmy had always lived in Cleveland, and still did when the story came out, so he called up *Ring Magazine* and raised heck about it. He said, "This guy is a 14 karat phony, I fought the real Jimmy Bivins and I should know the real one." Other great fighters have had plenty to say about Jimmy Bivins. I first met Jersey Joe Walcott, the 1951–52 Heavyweight Champion, in 1964, at a fight show at the old Cleveland Arena . I did not see him again until 1974, in Washington DC. During his lengthy conversation about his own career, Jersey Joe spoke of the importance of his February 1946 win over Jimmy in Cleveland, by split decision. Jersey Joe was on the comeback trail, and the win launched him into an eventual title shot against Joe Louis in December of 1947. It was a big win for him, and Joe told me without hesitation, "Jimmy Bivins was one of the three best fighters I ever met in my career. Tiger Jack Fox, Ezzard Charles, and Jimmy Bivins."

Clarence Henry, a heavyweight contender in the early 1950s, was another tough boxer Jimmy faced at the end of his career. When I met Clarence Henry in 1985, in California, the subject of Jimmy Bivins came up. It always did when I said I was from Cleveland, because Jimmy Bivins and Cleveland were synonymous in the boxing world. Clarence proceeded to tell me about his first fight with Jimmy, and how "he tricked me." When I asked him what on earth he meant by that, he explained that prior to their bout he was able to watch Jimmy work out in the gym a few times. But when it came time for their fight he faced an entirely differently looking Jimmy Bivins, and he was soundly whipped, and stopped in the eighth round. When I told Jimmy what Clarence said, he just laughed and said, "Shoot I never let on to people my style or how I was going to fight that particular night. I always adapted to the fight and fighter".

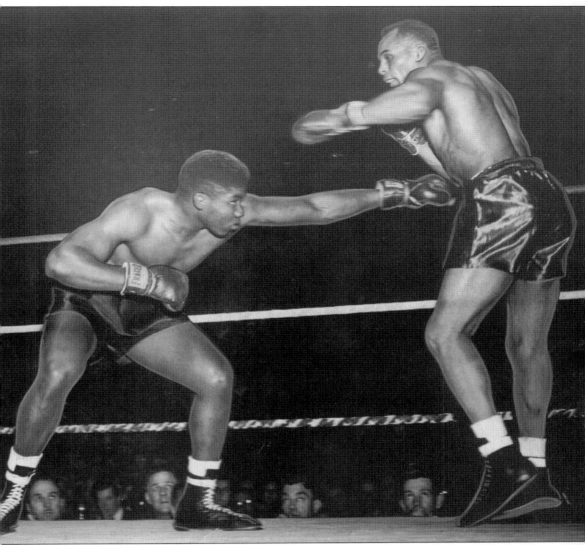

JERSEY JOE WALCOTT BACKS UP FROM JIMMY'S LONG LEFT, FEBRUARY 25, 1946, IN A SPLIT-DECISION WON BY WALCOTT.

Archie Moore, light-heavyweight champion from 1952 to 61, had a memorable five-bout series with Jimmy from 1945 to 1951. And there was some personal history between them too. The first time they met in August of 1945, in Cleveland, it is said that Archie was having a relationship with Jimmy's then wife, Dollree Map.

In the second round, Jimmy floored Archie and stood over him as he sagged, and hit him while he was down. The corner screamed for the referee, Jackie Davis, to award the fight to Moore, but on the advice of the commission, he only awarded him the round on a foul, and gave him time to recover. The longer the fight went, the worse it got, as Jimmy pounded Archie to the canvas several times, and finally stopped him in the sixth. After the fight, Jimmy said it looked like Archie was still fighting, and he did not mean to hit him when he was down.

It was revealed later on that Jimmy was furious that his soon to be ex-wife was actually

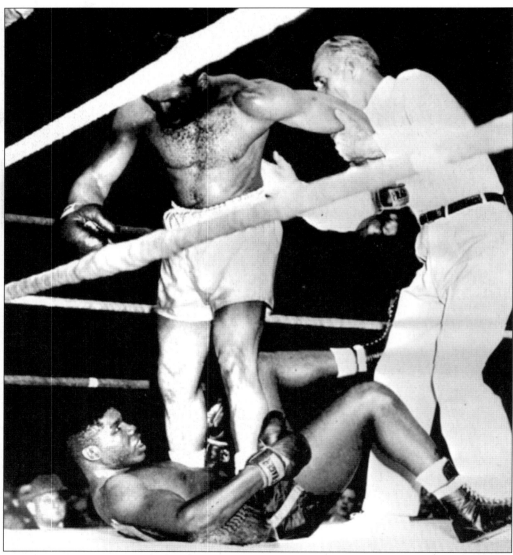

JIMMY GETS FLOORED IN THE EIGHTH ROUND AND EVENTUALLY STOPPED BY ARCHIE MOORE ON APRIL 11, 1949, IN TOLEDO, OHIO.

ringside rooting for Moore, but there was no doubt who was the better fighter that night.

In Peter Heller's book *In This Corner* Archie has some very unkind things to say about Jimmy Bivins. To his credit, he sought revenge the only way he knew how, and defeated Jimmy four times during the duration of their careers. But when I met Archie Moore in 1985, in Los Angeles, one of the first things he asked me was, "How is Jimmy Bivins?" And he seemed to have nothing but praise and admiration for Jimmy as a fighter. "It seemed every time I turned around I had to fight Jimmy, and it was never easy," he told me.

On October 29, 1994, Jimmy was to be inducted into the World Boxing Hall of Fame in Los Angeles. He had plane tickets in hand and was all set to go, when family problems prevented him from making the trip. And waiting and watching for him at LAX airport was none other than Archie Moore. Boxing earns mutual respect.

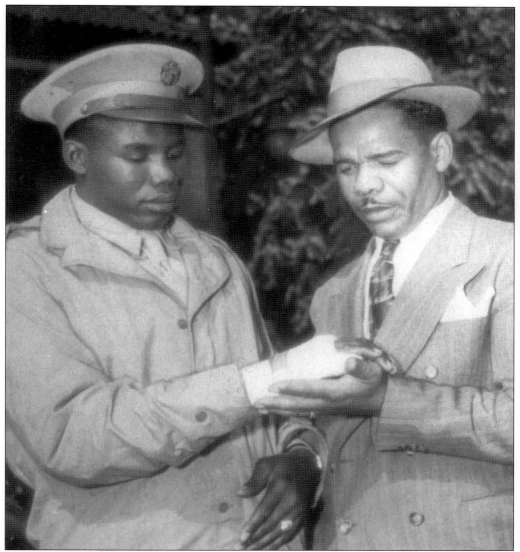

JIMMY BIVINS, PRIVATE IN THE US ARMY, HAS HIS DAMAGED HAND LOOKED AT BY LONGTIME MENTOR WILFRED "WHIZBANG" CARTER, SEPTEMBER OF 1944.

Jimmy Bivins and Joey Maxim get Checked by a Doctor Prior to Their June 22, 1942 Ten-Round Bout, Won by Bivins at Cleveland Stadium's "Bombers for

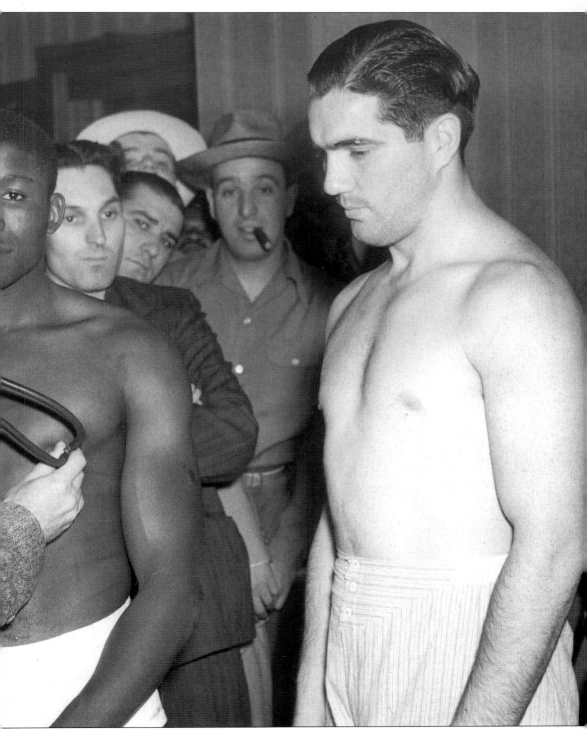

MacArthur" show.

Bivins, too, had plenty to say about his fellow greats. Traveling with Jimmy Bivins to various boxing dinners and functions over the years, and staying in hotel rooms with him, was always rewarding for me. Driving up to Rochester, New York, or Hamilton, Ontario, and other places, he would often reflect on his career and open up and tell me things he wouldn't have normally discussed.

Jimmy got to know big Big Red—the name affectionately given to the great Joe Louis, for obvious reasons—at golf tournaments and in training camps long before they ever met in the ring. Jimmy recalled one funny incident after he dropped a split decision to Jersey Joe Walcott in February of 1946. When he met up with Louis, Joe was all over him, saying, "What happened, Bivins? You let that old man beat you?" The next year, Louis defended his title against Walcott in December, was floored twice, and escaped with a split decision win. Louis even tried to leave the ring before the decision could be announced. When Jimmy met up with Louis the tables were turned. "What were you saying to me about that old man, huh, Big Red?" Jimmy laughed a good belly laugh when he told me this one.

When Jimmy and Ezzard were amateurs, they got to know each other quite well. There was always a mutual respect between them. When they met as professionals for the first time on January 7, 1943, Jimmy floored Ezz four times, and won a lopsided decision. He was accused of letting him off the hook, and was asked by the press why he hadn't knocked him out. Jimmy's reply was that he had him beat, and why humiliate him further? Later on, when Charles got the opportunity in a return match, he won a ten-round decision over Jimmy. And a year later knocked Jimmy out for the count in four rounds.

But one particular story Jimmy told me about Ezzard Charles involved their September, 1948 elimination bout in Washington, DC. The winner was supposed to get a shot at the title against Jersey Joe Walcott, to find a champion to replace the retiring Joe Louis. It seems, from what Jimmy told me, that there was a problem with the seating arrangements at the old ballpark for the nationally-televised bout, where the blacks in attendance could not get any seats anywhere near ringside. Well, Jimmy and Ezzard threatened to pull out and boycott the bout if things weren't changed, and from what Jimmy told me, things were changed quite a bit to their satisfaction. This is where their mutual respect came into play, they were opponents but they were friends too.

Another thing about this fight that has rarely been brought up is that Jimmy was approached "by the boys from New York" and asked to play ball with them. Jimmy had never let anyone handle his affairs except people he had himself picked, like Whizbang Carter and Claude Shane, from Cleveland.

Anyway, I have a copy of the film of this fight, and to most people who have viewed it, Jimmy won the decision. But in the end it went to Ezzard Charles, and he went on to win the heavyweight title from Jersey Joe Walcott. Was there something crooked about the fight? Hard to say, and nobody will ever admit it I am sure. But Jimmy said that even when the referee announced the decision it was almost at a whisper. Needless to say, Jimmy had refused to play ball, coining his most famous quote: "Heck I am a fighter, not a ballplayer."

Most people know Sandy Saddler is considered one of the all time greats in the featherweight division. He is, of course, most famous for his fights with another all time great, Willie Pep. All things considered, he was one of the best. Jimmy often ended up in training camps with some of the best fighters around, and on one particular occasion, he was in Joe Louis's training camp, in New Jersey, along with Saddler and others.

This is where the story gets funny. It seems that somehow Sandy managed to slip a snake into Jimmy's sleeping bag. Well, Jimmy did not then, nor does he now have a particular fondness for snakes, to put it mildly. He jumped up screaming and running, and shaking out his sleeping bag. Sandy Saddler apparently could not contain himself, and laughed real loud. When Jimmy found out it was him, he took his belt out of his pants, and tore after him, and as Jimmy told me, "I whipped his butt like a little boy."

Some years ago, Jimmy and I were guests at a dinner in Rochester, New York, and Sandy Saddler was also one of the guests. I had never met him prior to that, but after introductions, we got to talking, and with Jimmy standing by his side, I said, "Hay Sandy, by the way, what is this Jimmy tells me about a snake in a sleeping bag in Joe Louis's training camp?" The look on Saddler's face was worth a million—he looked like a child who got caught with his hands in the cookie jar.

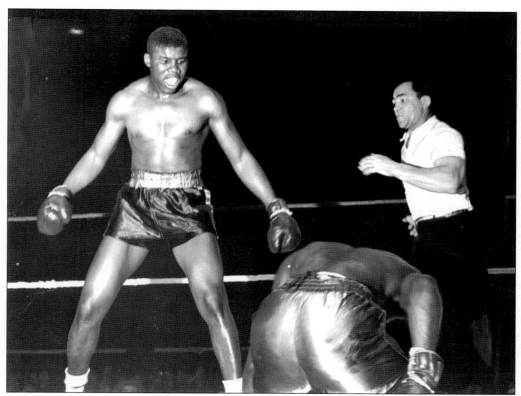

JIMMY FLOORS EZZARD CHARLES IN ONE OF HIS FOUR TRIPS TO THE CANVAS IN JANUARY OF 1943, AS REFEREE JACKIE DAVIS MOVES IN TO PICK UP THE COUNT.

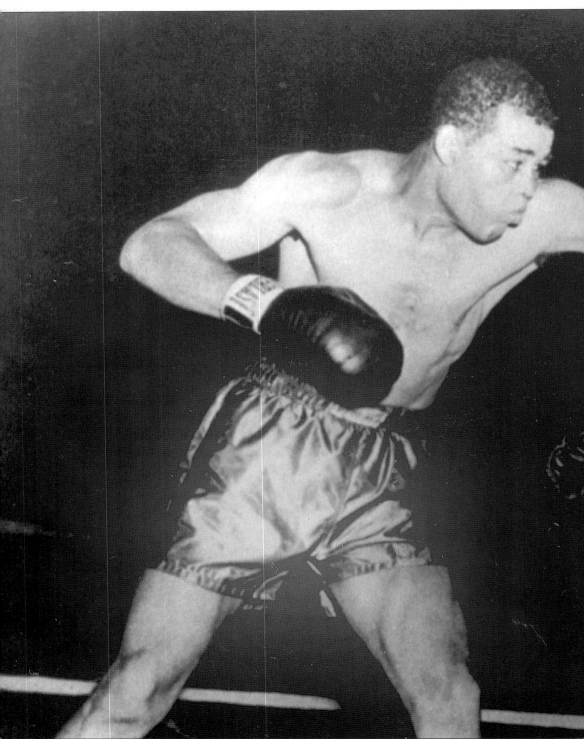

JIMMY BIVINS (RIGHT) SLIPS A JAB FROM FORMER CHAMP JOE LOUIS IN A TEN-ROUND

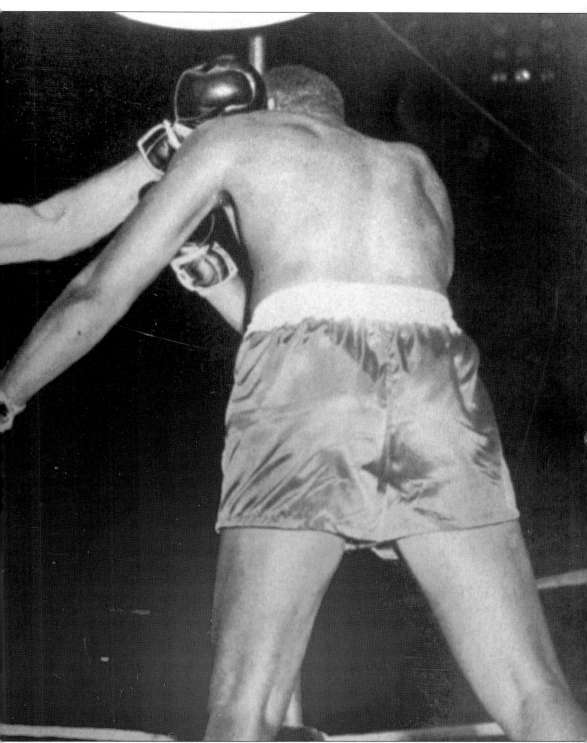

DECISION WON BY LOUIS ON AUGUST 15, 1951, IN BALTIMORE.

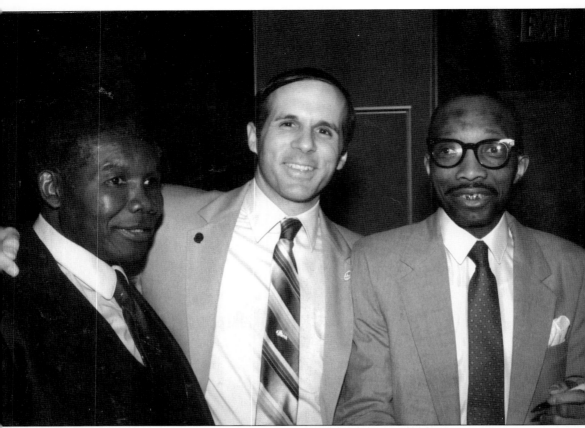

JIMMY BIVINS, JERRY FITCH, AND SANDY SADDLER IN ROCHESTER, NEW YORK, MAY 23, 1987. (Photograph by Tony Liccione.)

Eight
JOEY MAXIM

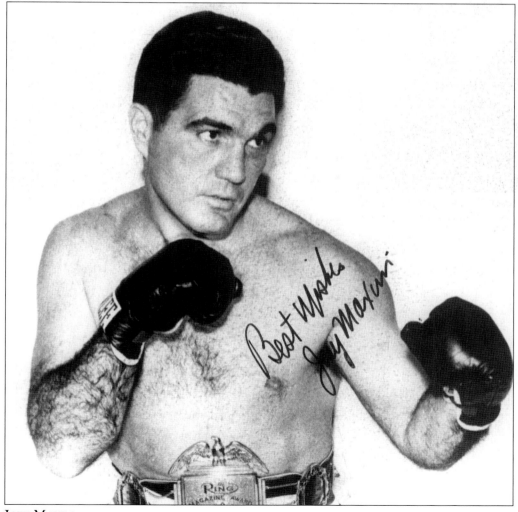

JOEY MAXIM.

Guiseppe Antonio Berardinelli was born in the Collinwood section of Cleveland on March 22, 1922. He was introduced to boxing very early in his young life, by a boyhood friend named Vic Rabersak. Needless to say, when his ring days came upon him, no poster, program, or marquee would have been large enough to hold the Italian's real name. And added to the fact that he threw left jabs in rapid fashion, ala the Maxim gun, an early version of the machine gun, he soon took on the name Joey Maxim.

With the Golden Gloves being very big in those days, Joey, like Lloyd Marshall, Jimmy Bivins, and others before him, got his feet wet in the fight game with amateur contests in the Cleveland Golden Gloves. And Joey was quite successful; he even won the National AAU in 1940. In 1941, Joey turned professional, and like Bivins, his amateur nemesis, he too started out meeting top-notchers almost from the beginning, not setups or "stiffs."

He learned his lesson well, losing only once in his first eleven contests that first year, and besting big names like Nate Bolden, Lee Oma, and Clarence "Red" Burman. Although a natural lightheavy, Joey wasn't afraid to meet the bigger men in the heavyweight division. Joey had a hard rock for a chin, and much boxing ability, but unfortunately he did not have the strength or punching power to take out the bigger men.

Although he conducted himself well against modest heavyweight opposition, and did pull off some big wins now and then, like his win against Jersey Joe Walcott later in his career, he usually was a bit in over his head when giving away so much weight to the better heavyweights.

Still, Joey was winning and making his way up the ratings, and even his losses showed he could hold his own with most anybody. In 1942, he lost to Jimmy Bivins, Booker Beckwith, Altus Allen, and twice to the great Ezzard Charles, although he could have very easily been given the decision over Charles the first time they met.

1943 started off well enough, until Joey took on Curtis "Hatchetman" Sheppard, a tough fighter, but one that Joey had already beaten by decision earlier that year in Pittsburgh. No one expected any trouble, and it figured to be a good payday in Cleveland for the boxing master.

But this time, something happened and Sheppard jumped on Joey and had him in trouble early. Before he knew what had happened, he was bent back through the ropes, and taking a serious pounding. Some people at ringside thought his neck might be broken, as the fight was stopped in less than one round.

Not only wasn't Joey's neck broken, neither was his pride or courage, for less than three weeks later he stepped into the ring with his conqueror, and easily won a ten-round decision. The previous knockout loss to Sheppard on March 10, 1943, was to be the only time Joey was ever stopped as a professional fighter. (He was knocked out by Jimmy Bivins in the amateurs.)

So, Joey showed he had what it took to come back and reverse a loss, especially a serious one like the Sheppard knockout. It turned out to be a fluke, and big punchers like Walcott, Moore, and Bob Satterfield, to name a few, never came close to stopping him again. Joey finished up the year by winning the rest of his bouts, and then entered the US Army as a Physical Education Instructor. He kept busy boxing, winning 14 out of 15 service bouts.

When Joey finished his Army duty, he continued winning, and the one thing that really turned his career around was when his friend Vic Rabersak sold his contract for $5,000 to Jack "Doc" Kearns. A lot has been said about Jack Kearns and how he handled his fighters' money. One thing is for sure, though, he had connections in the fight game, and could get his man the right matches and eventually title fights.

Joey continued to fight mostly in the heavyweight division from 1945 to 1948, because that is where "Doc" Kearns felt the money was. And Joey did defeat Phil Muscato, Charley Eagle, Ollie Tandberg, Buddy Walker, and Jersey Joe Walcott, all by decision. But the heavyweight champion was Ezzard Charles, someone Joey had a lot of trouble with, and Kearns eventually realized that the best chance for them to win a title would be at Joey's natural weight, lightheavy.

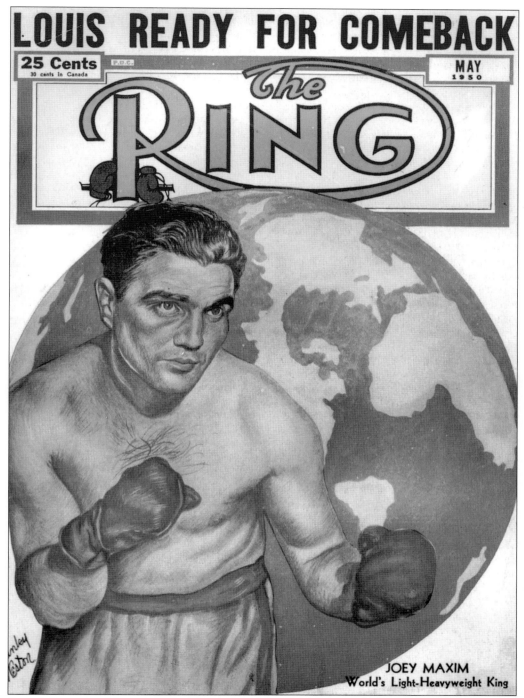

RING MAGAZINE, MAY OF 1950.

Gus Lesnevich had lost his world crown to England's Freddie Mills, but was still recognized as American Champion, so Kearns went after him first, and landed a match on May 23, 1949, in Cincinnati, for the American Light-heavyweight title, which Joey won in 15 rounds. Joey finished up the year by winning two surprising knockout victories over Joe Kahut and Pat McCafferty, and a decision win over Bill Petersen. Meanwhile, "Doc" got the go ahead for a fight with Mills, but it had to be in London, not America, so they were soon setting sail for the title match in England, January 24, 1950.

While I visited down in New Zealand in 1975, I had an interesting chat with former British Empire Middleweight Champion Bos Murphy, the first New Zealander ever to win the British crown, and Bos had some interesting things to say about Joey Maxim. Bos, as it turned out, was asked to be one of Joey's sparring partners, while he finished up training for the Mills match. Bos said, "I had been sparring with Joey for a few days and I was very much impressed with his boxing ability. He moved well, had a great jab, and wasn't easy to hit either. He complimented me on my ability, but I was the one who was really flattered. One day Maxim's manager and Mill's manager were watching us spar. I was approached by Mill's boss afterwards and asked what I thought. I told him Freddie didn't have a chance."

As it turned out, Bos Murphy was 100% correct, as Joey won easily, even knocked out a couple of Mill's teeth, and stopped him for the count in round ten, which in itself was a rare feat, because Joey was never known as a puncher. Cleveland had its second world champion, Guiseppe Antonio Berardinelli, more commonly known as Joey Maxim! And of course, there was a big celebration and Doc Kearns took most of the credit for making the match.

For the remainder of 1950, Joey lived it up, had some fairly easy matches, and all in all enjoyed life. He was in no big hurry to give up his newly-won crown, that is for sure.

On May 30th, 1951, in Chicago, Joey got his chance at the greatest prize in sports, The Heavyweight Championship. But the man who held that title was downstate rival, Ezzard Charles, and unfortunately Joey turned in one of his worst performances and lost a lopsided decision, lucky to finish on his feet. After the Charles loss, Joey finally put his light-heavy title on the line in a televised bout against Irish Bob Murphy, and he won a thrilling 15-round decision, on August 22, 1951, in New York.

And wouldn't you know it, he took on Ezzard Charles again, this time in a 12-rounder in San Francisco, on December 12, and once again it was a decision loss. He defeated trialhorse, Tiger Ted Lowry, and then came Joey's most famous fight, the Sugar Ray Robinson Yankee Stadium affair of June 25, 1952.

I suppose the critics will always say that Joey had no business winning this fight, which he eventually did when Robinson collapsed after 13 rounds, and could not answer the bell for the 14th. The heat that night was said to be at least 104 degrees and even the referee, Ruby Goldstein, collapsed and had to be replaced by Ray Miller in the 10th round. They will say Joey had no business winning, because Sugar Ray was beating him handily, boxing rings around him, easily ahead of him, no contest for most of the early going. But that is where he made his mistake. Outweighed, he used his superior speed to run rings around Joey, but also was using up a lot of energy. And Joey could lean on a man with the best of them.

Joey always told me, "Heck, I was fighting in that heat too, but I used my head, I took my time". Well, Joey won, that is what mattered, and call it luck or not, he was standing when it ended.

But the luck in the Robinson fight would not help him in his next contest, as he met another all time great, Archie Moore. Moore had waited years for a title shot, constantly fighting, and constantly winning. He didn't get his shot until "Doc" Kearns once again intervened and ended up being his manager.

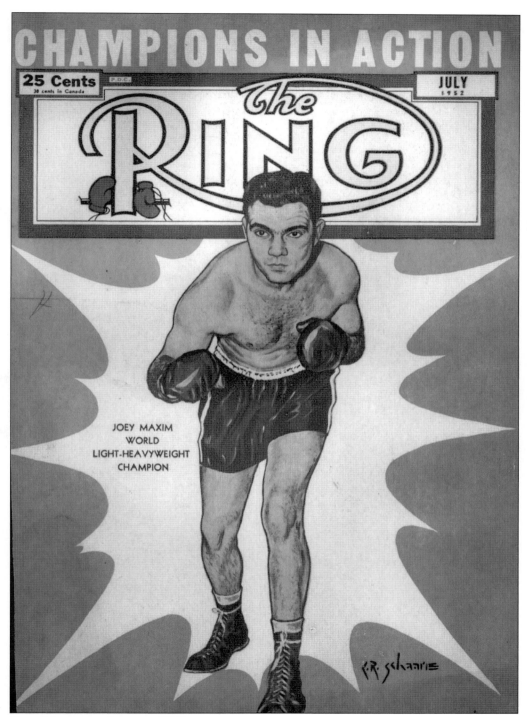

RING MAGAZINE, JULY OF 1952.

After 15 rounds of fighting on December 17, 1952, in St. Louis, the "Old Mongoose" had his hand raised, and there was no question as to who had won the fight.

Some say Joey won the return match with Archie on June 24, 1953, in Utah, but Moore got the decision again. And then in the rubber match on January 27, 1954, he left no doubt in Miami, Florida, as he whipped Joey a third time, this one not even close.

Joey's very next fight, after the third Moore contest, saw him squeak out an eight-round decision win over future heavyweight champ Floyd Patterson. None of the writers at ringside felt he had won that one either.

Anyway, the defeat was Patterson's first, but Joey was not to enjoy that feeling much more as his career really started to wind down. He would win only two more fights through mid-May 1958, and then retire. He lost eight of his last nine bouts, all by decision of course, and usually in the other guy's hometown—or in some cases home country—as he ventured as far as Italy and Germany.

Joey always told me, "Those were strictly hometown decisions, but I could see the end was near and I wasn't going to go anywhere." For the record he lost to Bobo Olson, Eddie Machen, and Willie Pastrano, among others, who were certainly not chopped liver. But the guys in Europe, well, Heinz Heushaus, Mino Bozzano, and Ulli Ritter don't exactly roll off the tongue as all time greats.

Joey left behind a record of 82 wins in 115 bouts, and has been entered into just about every hall of fame known to man, including two in Cleveland, The World Boxing Hall of Fame, The International Boxing Hall of Fame, and The Italian American Sports Hall of Fame. Without a

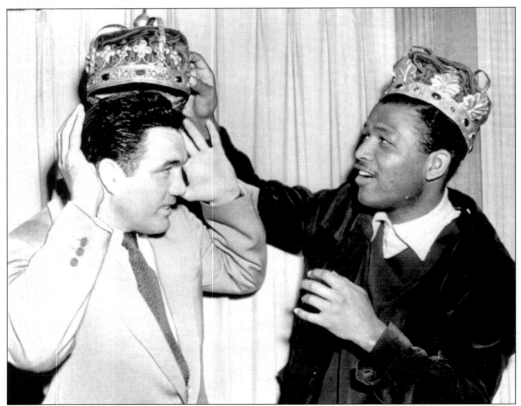

SUGAR RAY ROBINSON TRIED TO TAKE JOEY'S CROWN IN THEIR FAMOUS 1952 YANKEE STADIUM BATTLE, IN WHICH SUGAR RAY MELTED FROM THE HEAT.

doubt, Joey was Cleveland's last real link to fistic greatness, and yet the only ones who really appreciate him are the ones who love boxing, not the slugfests, but rather the science of it—the footwork, slipping punches, and all around boxing ability—things that Joey clearly displayed in the ring.

After suffering a stroke and other complications, Joey passed away on June 2, 2001, in Florida, where he had gone to be with his daughters. He was 79 years old.

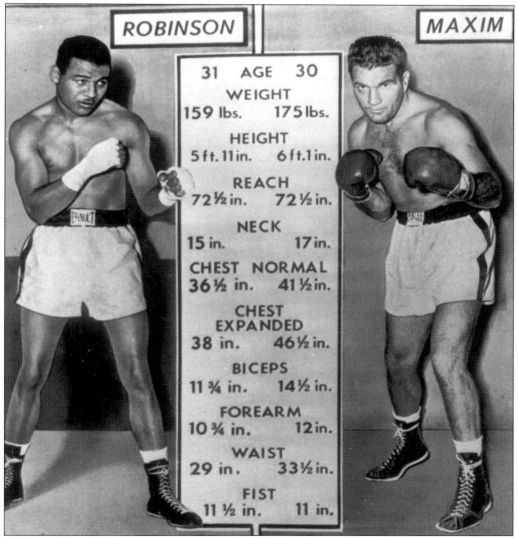

ROBINSON		MAXIM
31	AGE	30
	WEIGHT	
159 lbs.		175 lbs.
	HEIGHT	
5 ft. 11 in.		6 ft. 1 in.
	REACH	
72½ in.		72½ in.
	NECK	
15 in.		17 in.
	CHEST NORMAL	
36½ in.		41½ in.
	CHEST EXPANDED	
38 in.		46½ in.
	BICEPS	
11¾ in.		14½ in.
	FOREARM	
10¾ in.		12 in.
	WAIST	
29 in.		33½ in.
	FIST	
11½ in.		11 in.

TALE OF THE TAPE FOR THE JUNE 25, 1952 LIGHT-HEAVYWEIGHT TITLE FIGHT BETWEEN RAY ROBINSON AND THE CHAMP, JOEY MAXIM.

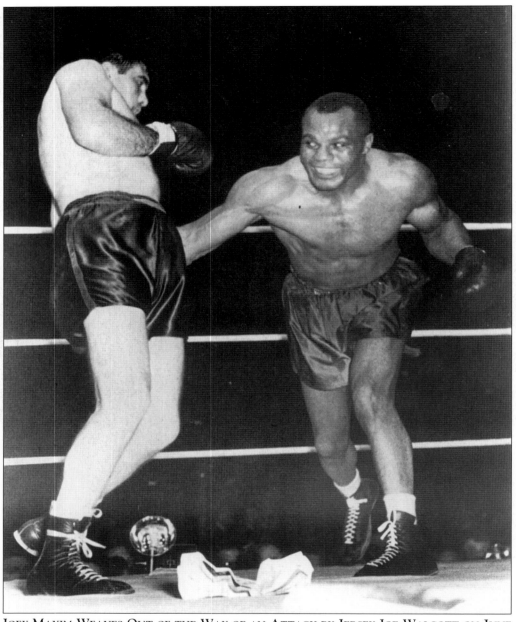

JOEY MAXIM WEAVES OUT OF THE WAY OF AN ATTACK BY JERSEY JOE WALCOTT ON JUNE 23, 1947, IN LOS ANGELES.

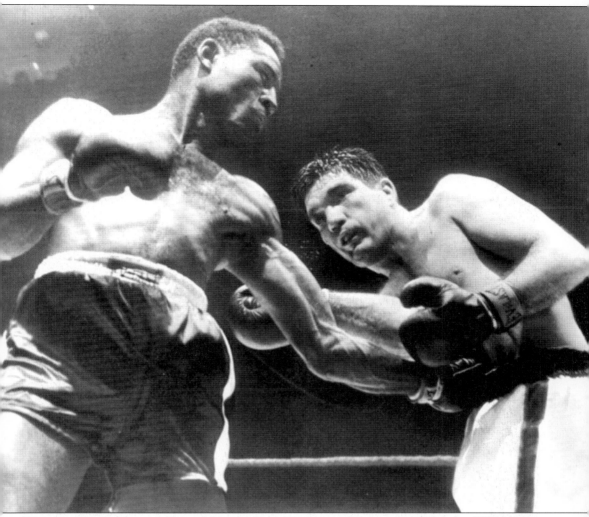

Ezzard Charles and Joey Maxim Get Tangled Up during Their 15-Round Heavyweight Championship Fight, Easily Won by Charles, May 30, 1951, in Chicago.

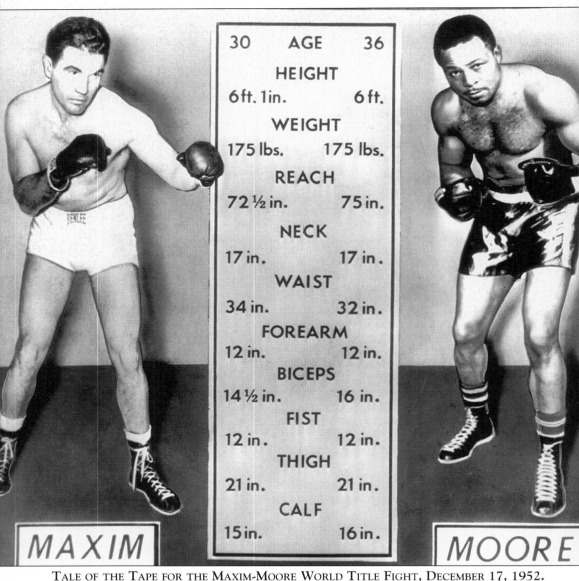

MAXIM		MOORE
30	**AGE**	36
	HEIGHT	
6 ft. 1 in.		6 ft.
	WEIGHT	
175 lbs.		175 lbs.
	REACH	
72 ½ in.		75 in.
	NECK	
17 in.		17 in.
	WAIST	
34 in.		32 in.
	FOREARM	
12 in.		12 in.
	BICEPS	
14 ½ in.		16 in.
	FIST	
12 in.		12 in.
	THIGH	
21 in.		21 in.
	CALF	
15 in.		16 in.

TALE OF THE TAPE FOR THE MAXIM-MOORE WORLD TITLE FIGHT, DECEMBER 17, 1952.

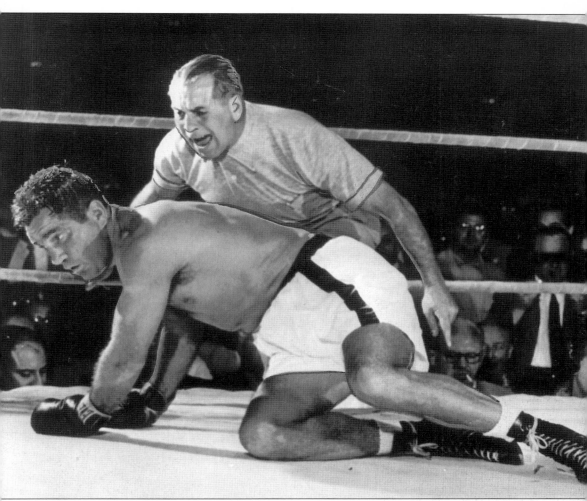

JOEY MAXIM ON THE FLOOR IN THE EIGHTH ROUND OF HIS THIRD FIGHT WITH LIGHT-HEAVYWEIGHT CHAMPION ARCHIE MOORE, JANUARY 27, 1954, IN MIAMI.

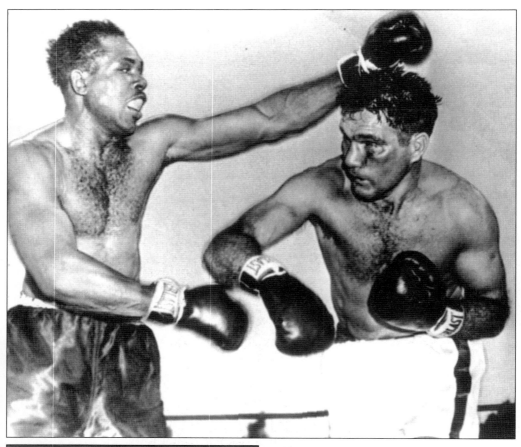

A Battered Joey Maxim Attacks
Archie Moore in Their Second Fight,
June 24, 1953.

Author Jerry Fitch with Joey Maxim
in Rochester, New York, 1996.

April 2010

S	M	T	W	T	F	S
				1	**2**	3
4	**5**	6	7	8	9	10
11	12	13	14	15	16	17
18	19	20	**21**	**22**	23	24
25	26	27	28	29	30	

15

March					2010	
S	M	T	W	T	F	S
	1	2	3	4	5	6
7	8	9	10	11	12	13
14	15	16	**17**	18	19	**20**
21	22	23	24	25	26	27
28	**29**	**30**	31			

May					2010	
S	M	T	W	T	F	S
						1
2	3	4	**5**	6	7	8
9	**10**	11	12	13	14	**15**
16	17	18	19	20	21	22
23	**24**	25	26	27	28	29
30	**31**					

16

7:00	
7:30	
8:00	
8:30	
9:00	
9:30	
10:00	
10:30	
11:00	
11:30	
12:00	
12:30	
1:00	
1:30	
2:00	
2:30	
3:00	
3:30	
4:00	
4:30	
5:00	

Nine
OTHER PROMINENT CLEVELANDERS

CARMEN BARTH. He was the 1932 Olympic Middleweight Champion, becoming a middleweight contender in the late 1930s. He fought Freddie Steele for the NBA middleweight title on Feb. 19, 1938, losing by seventh-round KO. In 44 bouts (29–13–2) Barth defeated Teddy Yarosz and Maurice Strickland, and fought Gus Lesnevich, Solly Krieger, Ron Richards, and Ken Overlin.

PHIL BROCK. This Russian-born Clevelander was a highly-rated lightweight pro from 1904 to 1916. In 75 bouts (33–9–9, 22 no-decisions, 2 no-contests) Brock defeated Tommy Murphy, Willie Beecher, George Memsic, Kid Taylor, and Frank Carsey; drew with Young Corbett, KO Brown; and fought Freddie Welsh, Harlem Tommy Murphy, Packie McFarland, Cal Delaney, and Owen Moran.

MATT BROCK. Brother of Phil Brock, Matt too was a highly-rated lightweight, and he fought professionally from 1912 to 1920. In 50 bouts (32–5–1, 12 no-contests) Brock defeated Johnny Griffiths, Kid Julian, Babe Picato, Bobby Reynolds, Eddie O'Keefe, and Rocky Kansas; drew with Johnny Dundee; and fought Frankie Britt, Willie Jackson, George Chaney, and Johnny Kilbane.

NATE BROOKS. This 1952 Olympic Flyweight Champion was a top ten ranked bantamweight in 1954. Brooks won the North American Bantamweight Title on Feb. 8, 1954, over Billy Peacock by an eighth-round KO. He lost the title to Ranton Mascia in a twelve-round decision on September 26, 1954. In 17 professional fights, he had a 14–3 record.

107

DOYLE BAIRD. He was an Akron/Cleveland rated middleweight, light-heavyweight pro from 1966 to 1972. In 43 bouts (35–7–1, 23 kayo wins) Baird defeated Stu Gray, Ted Wright, Don Fullmer, Earl Johnson, and Mike Pusateri; drew with Nino Benvenuti; and fought Emile Griffith, Vicente Rondon (for the WBA Light-Heavyweight Title) and Jean-Claude Bouttier.

ANTON CHRISTOFORIDIS. This Greek-born fighter lived and fought many bouts in the Cleveland area. He was a middleweight, light-heavyweight pro from 1934 to 1947. In 74 bouts (52–15–7) Christoforidis defeated Bep Van Klaveren (to win the European Middleweight Title), Lou Brouillard, Jimmy Reeves, Jimmy Bivins, Melio Bettina (to win the NBA Light-Heavyweight Title), and Ceferino Garcia, and fought Gus Lesnevich, Ezzard Charles, and Lloyd Marshall.

JACKIE DAVIS. He fought professionally as a lightweight and welterweight from 1930 to 1935. In 88 bouts (61–18–9) Davis defeated Sammy Mandell, Cocoa Kid, Honey Melody, and Izzy Jannazzo, and fought Wesley Ramey, Steve Halaiko, Bat Battalino, Lou Ambers .and Barney Ross.

JOHNNY FARR. He was a 1929–1930 top ten Jr. Lightweight. In 95 bouts (38–38–13, 6 no decisions) Farr defeated Freddie Miller, Jimmy McLarnin, and Ray Miller, and fought Tony Canzoneri (three times), Kid Chocolate (four times), and Barney Ross (three times).

JACKIE KEOUGH. He had over two-hundred amateur bouts, and won the 1944 Northeastern Ohio Golden Gloves. He also won the Cleveland Golden Gloves, the Chicago Tournament of Champions, and the National AAU, all at 147 pounds, in 1947. He fought as a welterweight and middleweight pro from 1947 to 1954. In 42 bouts (25–15–2) Keough defeated Lafayette Drummond, Germaine Gabouche, and Bobby Neal, and fought Eugene "Silent" Hairston, Randolph Turpin, Bobby Dykes, and Rocky Castellani.

LEM FRANKLIN. This Golden Gloves International Amateur Champion was also the 1937 National AAU runner-up. He was a ranked heavyweight pro from 1937 to 1944. In 45 bouts (30–13–1, 26 kayo wins, 1 no-contest) Franklin defeated Lee Savold, Abe Simon, Jimmy Bivins, Curtis Sheppard, Eddie Simms, and Tony Musto, and fought Bob Pastor, Joe Muscato, Gus Dorazio, Dan Merritt, and Larry Lane (Franklin died August 3, 1944, from injuries suffered in the Lane bout).

CHUCK HUNTER. He was a Golden Gloves Champ, Winner National AAU, at 135 pounds. In 1945, he was a top ten welterweight contender. In 70 bouts (45–23–1, lost by disqualification once) Hunter defeated Jackie Wilson, Artie Levine, and Steve Belloise, and fought Jimmy Doyle, Bob Satterfield, Jake LaMotta, Carl Bobo Olson, and Rocky Graziano.

CHARLEY O'CONNELL. He was a top ten ranked lightweight in 1924. In 64 bouts (43–5–1, 14 no-decisions, 1 no-contest) O'Connell defeated Jimmy Goodrich, Solly Seaman, Harry Kid Brown, and Johnny Dundee.

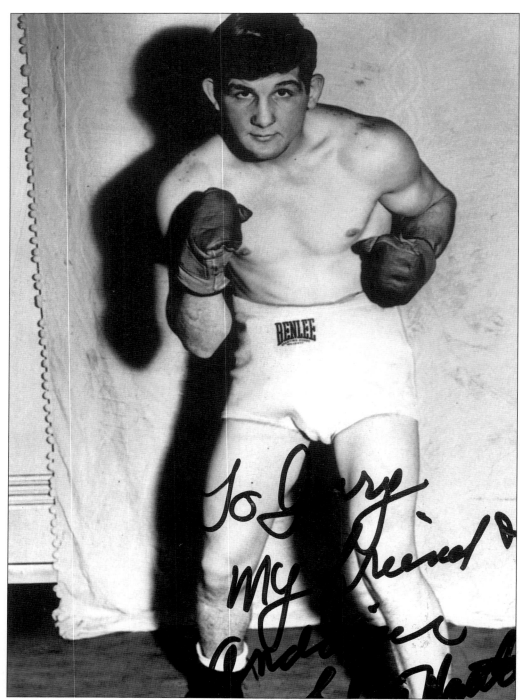

EDDIE MAROTTA. He was the 1947 National Golden Gloves Champion, at 126 pounds. He fought professionally from 1947 to 1950. In 34 bouts (27–5–2) Marotta defeated Pat Iacobucci, Gene Spencer, Corky Gonzales, Lino Garcia, and Rueben Davis, and fought Jackie Graves and Jim Rooney.

JIMMY REEVES. In 1939, he was a Golden Gloves, National AAU Champ, at 175 pounds, and a top ten ranked light-heavyweight in 1940. In 45 bouts (29–16) Reeves defeated Solly Krieger and Jake LaMotta (twice), and fought Teddy Yarosz, Anton Christoforidis, and Billy Soose.

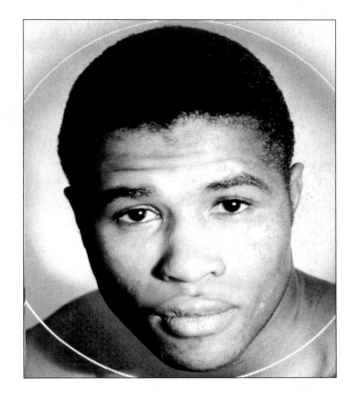

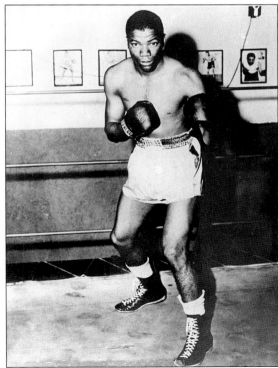

CECIL SHORTS. This welterweight fought professionally from 1956 to 1964. In 33 bouts (21–11–1) Shorts defeated Larry Boardman, Eddie Perkins, Vince Martinez, Isaac Logart, and Benny Kid Paret, and fought Luis Rodriguez, Phil Moyer, Gomeo Brennan, Virgil Adkins, and Jorge Fernandez.

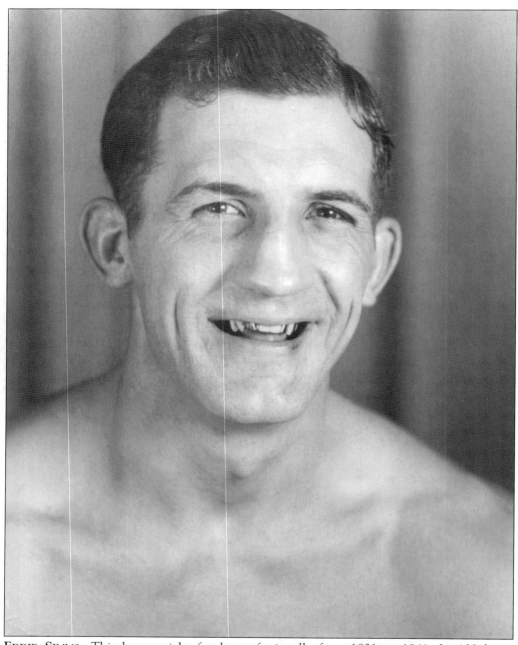

EDDIE SIMMS. This heavyweight fought professionally from 1931 to 1941. In 100 bouts (54–39–6, 1 no decision, 33 kayo wins) Simms defeated Lem Franklin (twice), Dan Merritt, Buddy Scott, Tony Musto, Kayo Christner, and Al Ettore; drew with Bob Pastor; and fought Joe Louis, Max Baer, Tommy Loughran, and John Henry Lewis.

"IRISH" BILLY WAGNER. A Golden Gloves champ, he fought as a pro light-heavyweight from 1968 to 1976. In 45 bouts (34–9–2, 23 kayo wins) Wagner defeated Roger Rouse and Hal "TNT" Carroll; drew with Mike Quarry (for the American Light-heavy Title); and Fought Don Fullmer, John Griffin, and Jorge Ahumada.

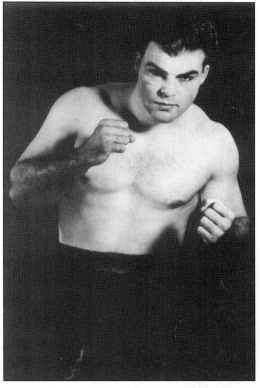

BILLY WALLACE. He was a top ten lightweight from 1926 to 1931. In 174 bouts (114–27–27, 6 no decisions) Wallace defeated Babe Herman, Kid Kaplan, Johnny Farr, and Billy Petrolle.

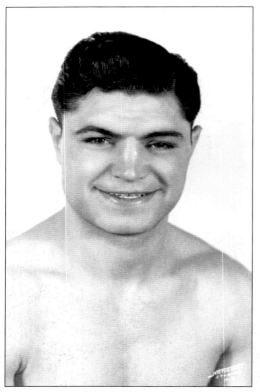

FRANKIE "CHEE CHEE" WALLACE. He was a top ten featherweight from 1931 to 1933, and a top ten lightweight in 1937. He had an amateur record of 81–7, before turning pro. In 131 bouts (65–57–9) Wallace defeated Freddie Miller and Frankie Klick, and fought Tony Canzoneri (twice), Lou Ambers, Bob Montgomery (three times), Tippy Larkin, and Sugar Ray Robinson.

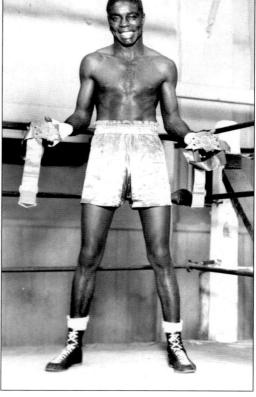

JACKIE WILSON. A winner of Cleveland, Chicago and New York Golden Gloves, he was also the National AAU champion in 1936, at 112 pounds. He was runner-up in the 1936 Olympics in Germany, and compiled a 50–1 amateur record, before becoming a top ten welterweight in 1941, 1942, and 1946. In 90 bouts (65–19–5, 1 no decision) Wilson defeated Ceferino Garcia, Cocoa Kid, Fritzie Zivic, Tommy Bell, Kid Azteca, Sammy Secreet, and Baby Arizmendi, and fought Chuck Hunter, Jake LaMotta, and Sugar Ray Robinson.

Ten
OTHER GREAT FIGHTERS COME TO TOWN

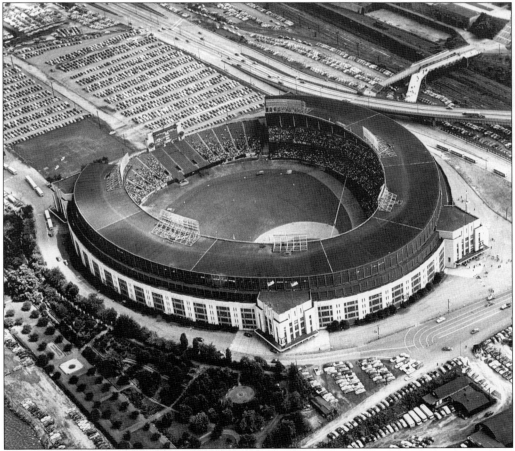

CLEVELAND MUNICIPAL STADIUM, 1931–1995. Along with the Cleveland Arena and Public Auditorium, this was the site of many important fights including Schmeling-Stribling, Bombers for MacArthur, and many fights involving Cleveland greats such as Jimmy Bivins, Joey Maxim, and Lloyd Marshell, as well as many out-of-town greats such as Archie Moore and Ezzard Charles.

SALAS-SADDLER, 1950. Battered challenger Laulo Salas forces Junior Lightweight Champion Sandy Saddler into the ropes. Saddler won via a ninth-round TKO and retained his title, April 18, 1950. (Photo by Nehez.)

CHRISTOFORIDIS-BETTINA, 1941. Anton Christoforidis (left) blocks a jab from Melio Bettina while winning the vacant NBA light-heavyweight title via a 15-round decision, January 13, 1941, at the Cleveland Arena.

ROBINSON-DOYLE, 1947. All-time great Sugar Ray Robinson stops challenger Jimmy Doyle in the eighth round of their welterweight title fight, June 24, 1947, at the Cleveland Arena. Tragically, Doyle hit his head after this blow, and died 17 hours later after surgery.

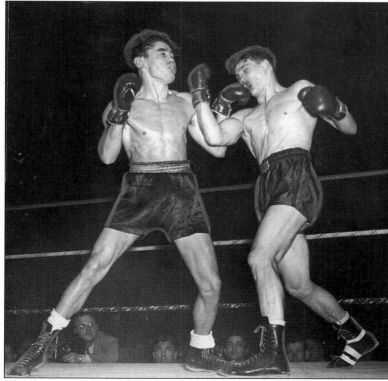

LEVINE-DOYLE, 1946. This award winning photo by the late *Plaine Dealer* photographer, Nobert J. Yassanye, shows Jimmy Doyle (left) and Artie Levine exchanging punches. Levine won by knockout in the ninth round, March 11, 1946, at the Cleveland Arena.

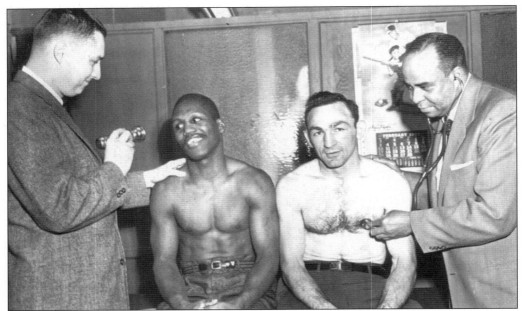

SAXTON-BASILIO WEIGH-IN, 1957. Johnny Saxton, the challenger, and champion Carmen Basilio (right) are checked by Cleveland Boxing Commission doctors for their February 22, 1957 welterweight title bout. Basilio won via second-round knockout. This was the first fight author Jerry Fitch ever attended.

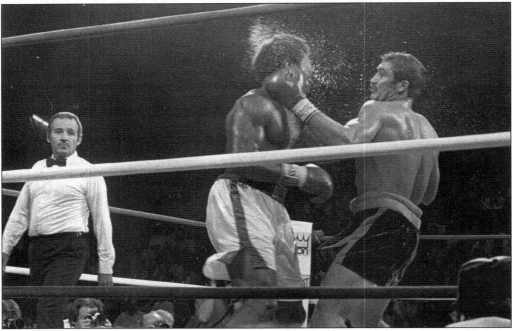

COETZEE-DOKES, 1983. Gerrie Coetzee of South Africa rocks Champion Michael Dokes with a left hook in the fifth round. Coetzee won the WBA Heavyweight Title via a ten-round knockout at Richfield Coliseum, September 23, 1983. (Photo by Terry Gallagher.)

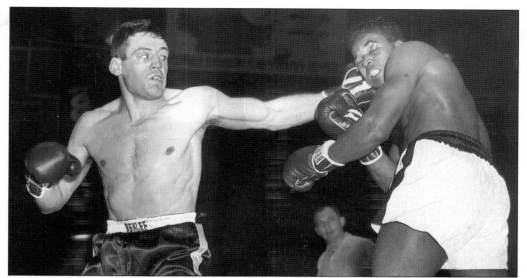

CASTELLANI-TURNER, 1953. Attilio "Rocky" Castellani of Luzerine, Pennsylvania, lands a hard left on Gil turner. Castellani won via a ten-round decision, December 9, 1953, in Cleveland. He compiled a a record of 9–1 in Cleveland during his fine career as a middleweight. (Photo courtesy of Terry Gallagher.)

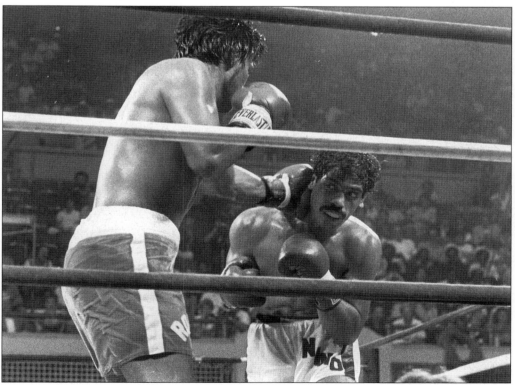

DURAN-GONZALEZ, 1981. All time lightweight great Roberto Duran (left) defeats Nino Gonzalez by decision, August 9, 1981, at the Cleveland Public Auditorium. (Photo by Terry Gallagher.)

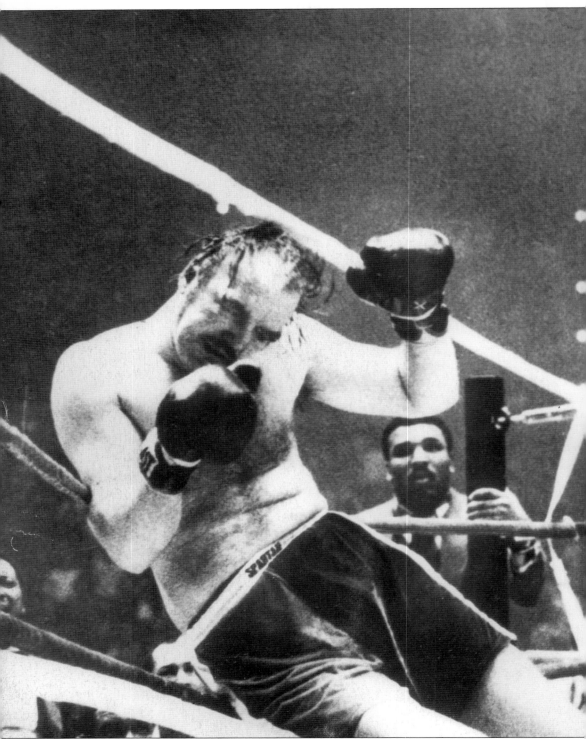

ALI-WEPNER, 1975. Muhammad Ali floors challenger Chuck Wepner at the Richfield

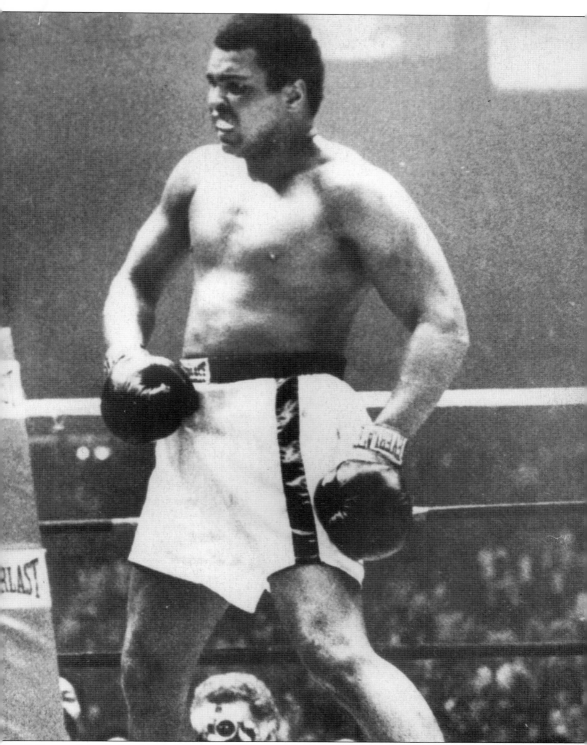

Coliseum, March 24, 1975. Ali stopped Wepner in the 15th round by TKO.

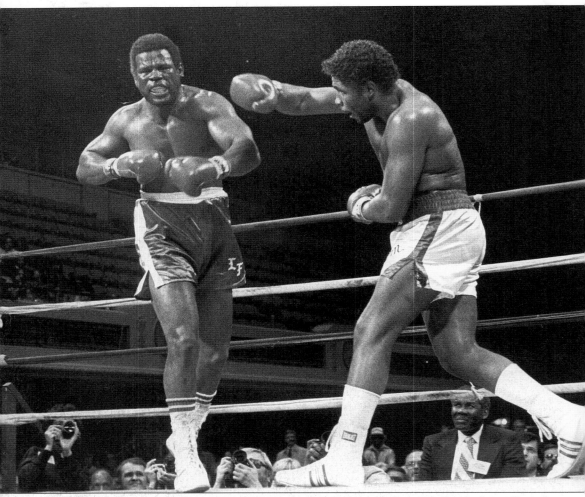

PAGE-FRAZIER, 1983. Future WBA Heavyweight Champion Greg Page rocks Larry Frazier in the second round, February 12, 1983, at the Cleveland Public Auditorium. Page won in ten rounds. (Photo Terry Gallagher.)

GIARDELLO-RIVERO, 1964.
Middleweight champion Joey
Giardello (left) outworked Rocky
Rivero to win a ten-round non-
title decision at the Cleveland
Arena, April 17, 1964.

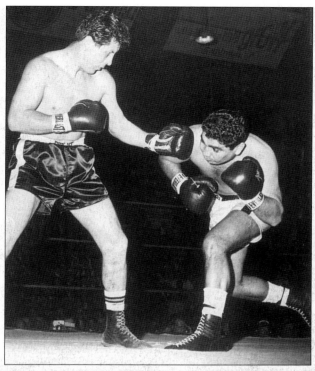

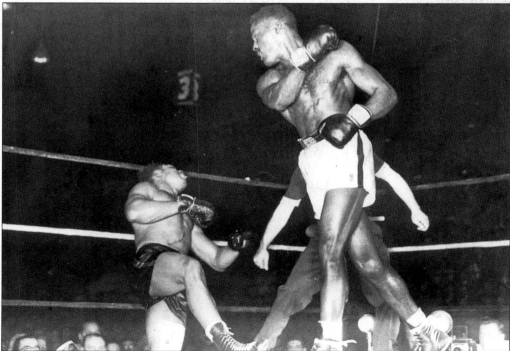

CHARLES-MOORE, 1948. Future heavy-weight champion Ezzard Charles stops future light-heavy
champ Archie Moore in the eighth round, January 13, 1948, at the Cleveland Arena.

(Photo by Pat Orr.)